FIRST FLOOR PLAN SCALE ¼" = ONE FT.
SUMMER RESIDENCE FOR FRED B. JONES, ESQ.
TO BE BUILT AT LAKE DELAVAN, WIS.
FRANK LLOYD WRIGHT ARCH'T. OCTOBER 1900

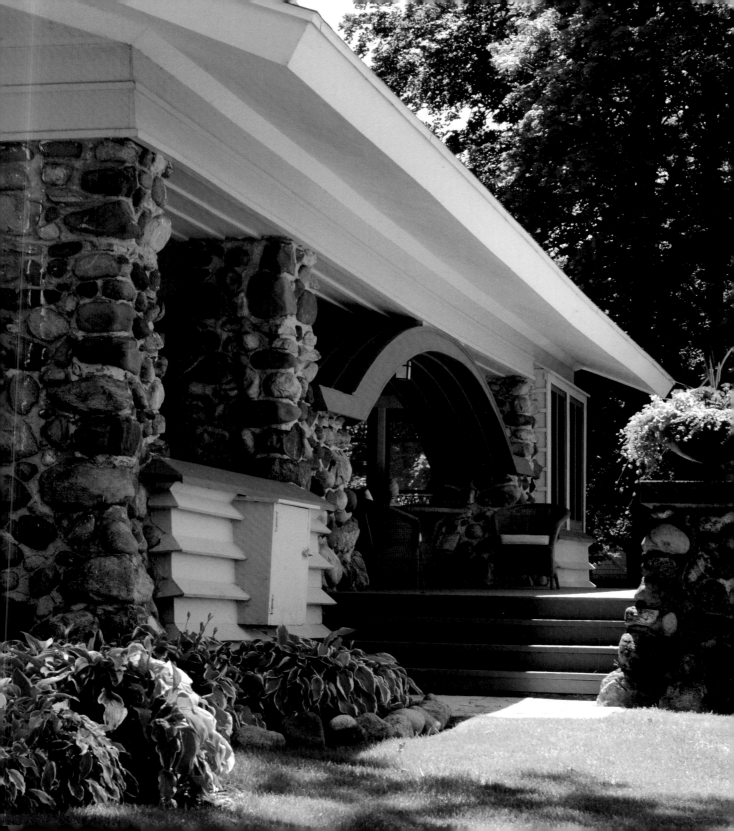

Frank Lloyd Wright's
PENWERN
A SUMMER ESTATE

Text and Photographs
by Mark Hertzberg

Wisconsin Historical Society Press

Published by the Wisconsin Historical Society Press
Publishers since 1855

The Wisconsin Historical Society helps people connect to the past by collecting, preserving, and sharing stories. Founded in 1846, the Society is one of the nation's finest historical institutions.

Join the Wisconsin Historical Society: wisconsinhistory.org/membership

Publication of this book was made possible in part by generous gifts from
Sue and John Major and John K. Notz Jr.

Printed in Canada
Designed by Brad Norr Design
23 22 21 20 19 1 2 3 4 5

Library of Congress Cataloging-in-Publication Data
Names: Hertzberg, Mark, 1950– author.
Title: Frank Lloyd Wright's Penwern : a summer estate / text and photographs by Mark Hertzberg.
Description: Madison, WI : Wisconsin Historical Society Press, 2019. | Includes bibliographical
 references and index. |
Identifiers: LCCN 2018048764 (print) | LCCN 2018049742 (e-book) | ISBN 9780870209116 | ISBN
 9780870209109 (hardcover : alk. paper)
Subjects: LCSH: Wright, Frank Lloyd, 1867–1959—Criticism and interpretation. | Penwern (Wis.) |
 Jones, Fred B., 1858–1933—Homes and haunts—Wisconsin—Delavan Lake Region (Lake) | Lakeside
 architecture—Wisconsin—Delavan Lake Region (Lake) | Vacation homes—Wisconsin—Delavan
 Lake Region (Lake)
Classification: LCC NA737.W7 (e-book) | LCC NA737.W7 H463 2019 (print) | DDC 720.92—dc23
 LC record available at https://lccn.loc.gov/2018048764

Fred B. Jones had a dream for a country estate. Frank Lloyd Wright helped him realize that dream. This book is dedicated to the Robbins family, to John O'Shea, and to Sue and John Major, all of whom have played a part in ensuring Penwern remains an enchanting home on the shores of Delavan Lake.

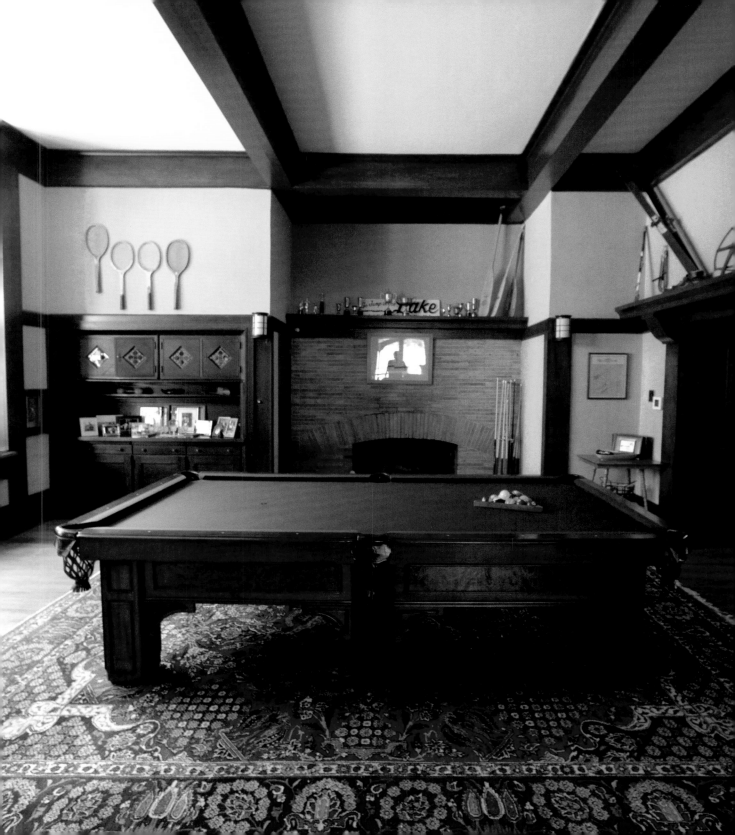

Contents

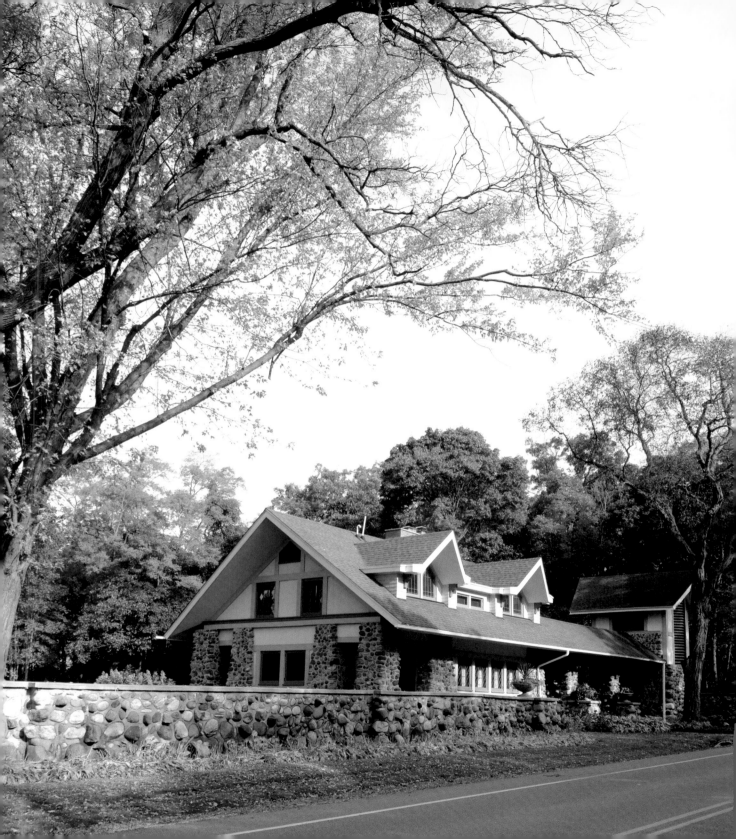

Foreword

Penwern, the magnificent summer house designed in 1900 by Frank Lloyd Wright for business executive Fred B. Jones, enthralls the visitor by the magic of its very existence— the generosity of its forms and setting, its lively interior expanses, its enchanting bridge and tower, its captivating gate lodge and stables, and its riveting boathouse. All of these are the subjects of Mark Hertzberg's illuminating study.

Penwern can be further understood and appreciated by trying to answer a series of questions. How does the Jones weekend estate fit into Wright's overall architectural development? How does it compare with his other summer homes, or with other vacation houses by his Prairie School colleagues? How does it relate to the myriad other lakeside retreats built for Chicagoans on lakes in Wisconsin and Michigan? And what is its context on the shores of Delavan Lake? The answers are relevant to a full understanding of this inspired work by one of America's master architects.

Penwern is both the most ambitious of the fifteen summer houses Wright designed between 1891 and 1916 and the most important in the development of Wright's architecture.[1] As a group, the summer houses have been quickly passed over in standard texts on Wright's architecture. Even where they have been given some attention, Penwern has been neglected in favor of the smaller, wooden vacation houses. For example, in his extensive monograph *Frank Lloyd Wright, Architect*, Robert McCarter devoted some attention to what he called the "board and batten cottages," where "Wright's careful orchestration of the economies necessitated in simple wood construction achieved an exceptional coherence of form."[2] In the catalog to an exhibition of Wright's Wisconsin work, architect Jonathan Lipman critiqued the Delavan houses as

The gate lodge—the only building at Penwern visible from the road—provides a tantalizing hint of the estate's splendor.

"[Wright's] attempts at evoking a feeling appropriate to the natural setting [that] were achieved by a collision of rustic and exotic architectural elements."[3]

Two of the wooden summer cottages have received particular attention. Already in 1942 architectural historian Henry-Russell Hitchcock dubbed the Charles S. Ross House, built in 1902 on Delavan Lake near Penwern, "the finest of the 'Forest' houses which are the more rustic brothers of the Prairie houses."[4] The Ross House famously attracted the attention of Wright scholar H. Allen Brooks, who developed his argument about Wright's achievement in "breaking the box" on the Ross plan, with its interconnected rooms.[5] Secondly, the George Gerts Cottage at Whitehall, Michigan, also built in 1902, has been studied both for its modular planning of four-by-four posts set on 36-inch centers and its bridge that crosses a shallow ravine.[6]

Yet Penwern, a major work of Wright's great experimental year of 1900—and one that bears as much comparison with his major residential buildings of the time as with frame cottages—has awaited detailed analysis until now.

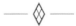

As he turned twenty-six in June 1893, Frank Lloyd Wright had just severed his connections with the Chicago firm of Adler & Sullivan, where he had worked for slightly more than five years.[7] The primary influence evident in the few independent designs he had produced up to that point reflected the picturesque compositions fostered by the architects of the so-called Shingle style, an approach to design imparted to Wright through his first employer, Joseph Lyman Silsbee. Silsbee's cemetery chapel created for the Lloyd Jones family in 1886 (they were cousins of Wright's, and the chapel's kitchen ostensibly was Wright's first design job) presents rough cut and stained cedar shingles over a textured limestone base. Yet the two buildings Wright designed just before and immediately following his leaving Adler & Sullivan exhibit the strong influence of Louis Sullivan's new architecture. Both the preliminary sketches for the Orrin Goan House and the revised version built for William Winslow are formally arranged around a central axis marking their entrances. Large double-hung plate-glass windows light the ground floor, while Wright's own version of Sullivan's abstracted, botanic ornament graces the stone work around the entrance and the plastered second-story frieze.

The inclusion of elements derived from Sullivan's formal expression revealed a fundamental dilemma facing Wright. From Silsbee, he had learned a manner of composition and an interest in the materials of construction but virtually nothing about architectural theory and its relation to the meaning of style. In contrast, these were subjects that obsessed Sullivan, who was eager

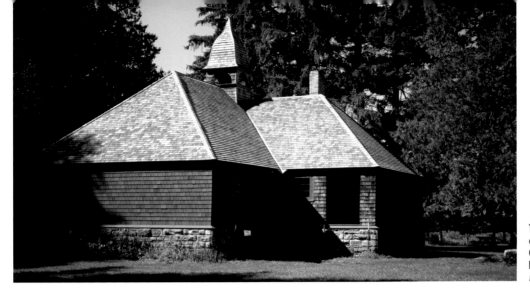

The Lloyd Jones family cemetery chapel in Spring Green, Wisconsin, designed by Joseph Lyman Silsbee
Photo by Paul Kruty

to expound at length upon them, particularly to his young protégé. Sullivan thus transferred to Wright the very idea of creating a contemporary architecture that responded to the needs and wants of modern life, an architecture that freely accepted the materials that would make this possible, whether these were new or old, and would do so by way of a new vocabulary of form and decoration.

Throughout the 1890s, Wright experimented with a variety of arrangements, decorative schemes, and materials before he developed the architectural vocabulary that he would use consistently from 1902 through the first decade of the twentieth century—what has come to be known as his Prairie style. He first developed the severe geometry, simplicity, and symmetry as well as the decorative richness of Sullivan's architecture in such constructed buildings as the Winslow House in River Forest (1894), the Isadore Heller House in Chicago's Hyde Park

William Winslow House, River Forest, Illinois

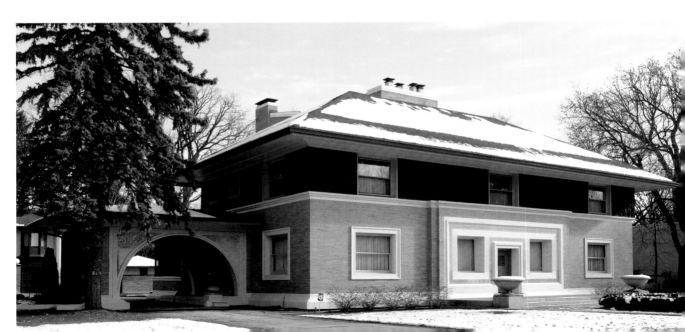

neighborhood (1897), and the Helen Husser House in Chicago (1898). He simultaneously investigated a wide range of prototypes far removed from Sullivan's influence, including continuations of the picturesque Silsbee lineage, and forays into a variety of historic styles, including Classical Revival, Tudor Gothic, and Dutch Colonial.

The culmination of his Sullivanian development was the lakeshore mansion in Chicago for Helen and Joseph Husser, begun late in 1898 and finished in 1899.[8] This brick, stone, and terra cotta building was his great tour-de-force of complete design up to that point. While he generously employed Sullivanian motifs—arcades, columns, simple masses, and sharp edges—and covered them with his own version of his mentor's modern ornament, Wright developed an interior spatial arrangement far beyond anything Sullivan designed. Though indebted to the liberating effect of the Shingle style, it also transcended anything Silsbee had produced. In June 1900 the Husser House was prominently featured in the first important article written about Wright's architecture, the grand monographic issue of the Boston journal *Architectural Review* devoted to Wright's work, written and arranged by his colleague and close friend Robert C. Spencer Jr.[9] Was this building the first announcement of the new American residential architecture?

Helen and Joseph Husser House, Chicago
Photograph by Henry Fuermann, published in Architectural Record, July 1905

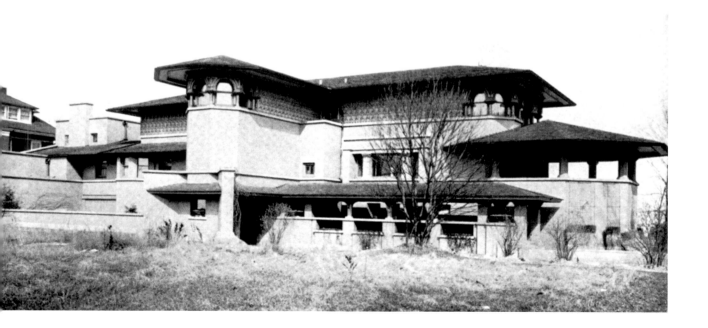

It certainly appeared so at the time. Soon after the Husser House was completed, Wright showed it off to C. R. Ashbee, the influential English arts-and-crafts architect and artisan, then on an American tour. As Ashbee recorded in his journal, "[Wright] not only has ideas, but the power of expressing them and his Husser House over which he took me, showing me every detail with the keenest delight, is one of the most beautiful and most individual of creations that I have seen in America."[10]

And yet Wright was not satisfied. Once and for all he was determined to find a new solution to the dilemma of creating a modern mode of architectural expression for contemporary America. He began to experiment anew with a variety of forms, techniques, and motifs, many of which found expression at Penwern. Indeed, Penwern served as the crucible for the reinvestigation of the liberating effects of picturesque materials, non-Western style, and spatial interplay, all with the goal of creating a viable vocabulary of form. And 1900 proved to be a very crucial year in Wright's development.

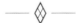

Instead of the Husser House being the resolution to Wright's quest, it was the end of a particular line of investigation. Immediately afterward Wright began a series of designs utterly unrelated to the Sullivanian group and one that within two years was to produce his first consistent modern system of design in his Prairie style.

The change occurred most clearly in a design for a golf clubhouse—a new building type that lent itself to an informal expression. For the River Forest Golf Club, designed early in 1899 while the Husser House was being built, Wright created a simple framed structure, its low walls articulated with flat boards whose joints were sealed with battens.[11] In this vernacular building method used on barns and outbuildings, and taken up for prefabricated wooden churches in the early Gothic Revival, the exterior boards were meant to be placed vertically. At his golf clubhouse, Wright placed them horizontally, which rather defeated the battens' purpose of shedding rainwater but presented a novel articulation. Wright then capped the entire building with a unitary hipped roof, providing a long horizontal line to match the battens.

Although this unusual building might seem precocious, signaling as it does the beginning of Wright's Prairie style, the architect apparently did not see it that way, for he only returned to it as a paradigm more than two years later. Rather, he launched into a whole series of experimental buildings. In 1899, those included projects for the sprawling Henry Cooper House and the late Sullivanesque C. A. McAfee House.[12]

River Forest Golf Club, River Forest, Illinois *Published in* **Architectural Review,** *June 1900*

At year's end, a truly surprising change occurred in Wright's architecture. He prepared plans for a summer house to be built south of Chicago for a judge who wanted a place to escape the city's hot summers. The informal nature of the commission allowed Wright to indulge in a further bit of experimentation: he looked for inspiration to Japanese architecture, a system of design that he was familiar with since his days with Silsbee and one that he had experienced firsthand in 1893 at the Chicago World's Fair. The Japanese teahouse known as the Ho-o-den (see page 36) sported the gable-and-hip *irimoya* roof, with its turned-up corners, that particularly attracted the architect. Without wishing to indulge in yet another revival style, albeit an alien one, Wright was intent on exploring the forms found in a foreign architecture as a means of breaking through to a new vocabulary of design.

Construction documents for the Stephen A. Foster House were complete by January 1900, while a perspective rendering, dated February 24, 1900, was prepared just in time to be included in Spencer's monograph for *Architectural Review*.[13] Although basically a picturesquely composed shingled house, the Foster design appeared decidedly "oriental" from the street, beginning with its apparent *torii* gate at the entrance to the yard. The flared roof ends above the gables, while not related to the ridge line of the Ho-o-den but rather the upturned ends of its lower roof, are striking features of the Foster House.

Shortly after Wright began work on the Foster House, he was approached by clients who wished to build houses in Kankakee, Illinois, fifty miles south of Chicago. Warren Hickox and his sister, Anna Bradley, visited Wright "during the winter of 1900," as Hickox later recalled, presumably in January.[14] By March, Hickox was ready to announce his intention to "build a handsome residence this season."[15] In April, the two families—the Bradleys and the Hickoxes—filed an agreement about the four lots on which they would build their two houses.[16] Two months later Wright was ready to turn over his sketches to office drafters, who completed working drawings dated June 1900. Construction began in July, while in October it was reported that the houses "are receiving their exterior finish which is plaster."[17] By January 1901, the houses were completed to the extent that a local reporter was afforded a tour of each.[18] Citing these dates is crucial because Penwern was on the boards during much of this time.

Wright's house for Laura and Warren Hickox repeated the flared gable ends used on the Foster House, now combined with plastered walls and stained wood "half-timbering" and with casement windows grouped in bands. The ingenious plan combines the three principal rooms into a single space set cross-axially in front of the central fireplace with service spaces to the rear.

Stephen A. Foster
House, West Pullman
(Chicago), Illinois

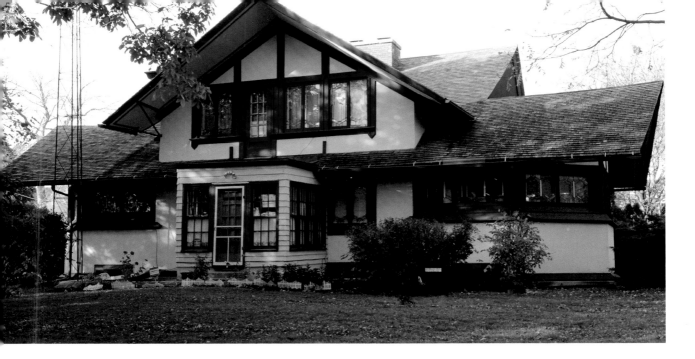

Laura and Warren Hickox House, Kankakee, Illinois

Elevation drawing of the Anna and B. Harley Bradley House, Kankakee, Illinois
Library of Congress/ Historic American Buildings Survey

In his house for Anna and B. Harley Bradley, Wright again used the flared gable roofs of the Foster and Hickox Houses and the latter's plaster, stained-wood trim, and grouped casement windows. On the broad porches he added brackets and low arches clearly derived from the Tudor revival style. Once again, the plan is striking in its deployment of living and dining room as freestanding spaces set at right angles to the central fireplace, the entranceway and service wings completing the four parts of a pinwheel.

These general characteristics led the first reporters describing the houses to declare them to be "of the Swiss chalet style of architecture," while Warren Hickox himself later characterized them as "of the English style," decrying the difficulty of finding a builder "who was supposed

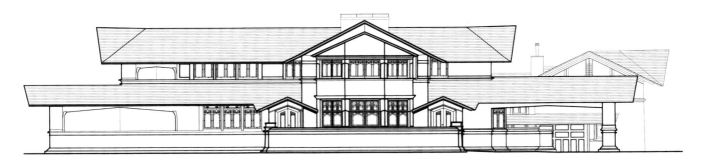

EAST ELEVATION
SCALE: 1/8"=1'-0"

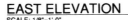

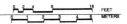

FEET
METERS

to understand English construction."[19] Clearly the unusual use of stucco for exterior surfaces suggested English medieval architecture, as, indeed, Wright himself had used it in 1895 in his frankly Tudor Revival mansion designed for Chicago attorney Nathan Moore. But here it becomes a unifying surface, much as the earlier shingles had been, yet now without their textured surfaces.

Wright's immediate response to the success of the Bradley and Hickox Houses was to publish versions of the two in the popular magazine *Ladies' Home Journal* as "A Home in a Prairie Town" and "A Small House with 'Lots of Room in It.'"[20] But the two houses were so rich in ideas that Wright spent the next few years working out the many possibilities inherent in their plans and elevations.

While these auspicious events were underway, Wright had undertaken the first of a series of summer homes being constructed on Delavan Lake, a clear body of water just across the Wisconsin border and west of Geneva Lake, a larger if similar glacial "pond" frequented by Chicago's Gold Coast elite. The development was the brainchild of fellow Oak Parker Henry H. Wallis, for whom Wright designed a cottage in summer 1900, its working drawings dated October 1, 1900, but which was not constructed.[21] This hip-roofed house was replete with field-stone boulders on its lowest level, lap siding above, and lighted with diamond-paned casement windows, as is apparent on a sketch elevation by Wright dated September 15, 1900.

Although Wallis was in the business of developing small lots to accommodate modest summer cottages, the major commission that came to Wright for a site on Delavan Lake was from a wealthy executive who contemplated a grand resort mansion. Fred B. Jones was managing director at Adams & Westlake, makers of railway supplies, whose eventual president was Ward Willits, soon to be a Wright client himself. And Jones wanted a bachelor pad extraordinaire.

While Jones only began acquiring lots, mostly from Henry Wallis, between September 11 and October 17, 1900, and the working drawings prepared by Wright's staff are similarly dated "October 1900," Wright was clearly turning around ideas about the house in his mind for some months before.[22] The final elevation drawings show a complex composition that marries "country" forms of boulders and horizontally articulated framing with elements developed at the Foster and Bradley Houses and, unlike the hipped roofs proposed for Wallis, an emphatic use of expressive gable roofs with upturned ends.[23]

The commission for a summer house from Fred B. Jones in 1900 came to Wright at a pivotal period in his architectural development, one in which he was open to a wide variety of influences as he looked for a usable vocabulary of form. Two architects whose work can help set Penwern in its contemporary context are figures intimately involved in Wright's development yet barely

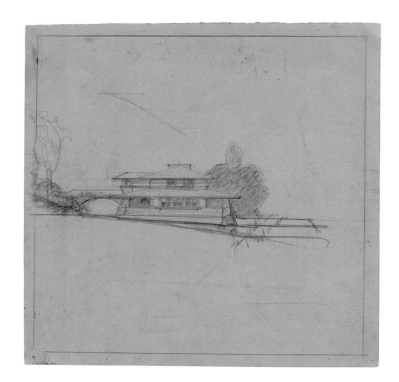

Elevation drawing of
the Henry H. Wallis
House scheme 1,
Delavan Lake, Wisconsin
© 2019 Frank Lloyd Wright
Foundation, Scottsdale, AZ.
All rights reserved.

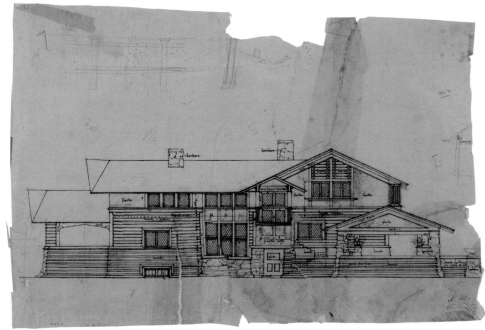

Elevation drawing of the
main house at Penwern
© 2019 Frank Lloyd Wright
Foundation, Scottsdale, AZ.
All rights reserved.

mentioned in Wright studies: Robert C. Spencer Jr. and Walter Burley Griffin. Spencer was Wright's closest colleague, confidant, and mentor from 1894 to 1901. Griffin, his chief employee and virtual partner from early 1901 through 1905, was intimately associated with the creation of most of the dozen summer homes created after Penwern, including the group on Delavan Lake, as well as Penwern's 1903 gate lodge.[24]

One of the most unusual elements at Penwern at first glance is the two-and-a-half-story tower connected to the house by an open covered walkway at the second level, supported by a low archway. The walkway's low-pitched roof continues as a skirt across the tower, ending in a gable, incorporating the tower into the composition of the house. The tower is capped with a gable roof, set crossways to the gable below it but aligned with the main gable of the house. Although apparently the tower's primary purpose was to hold a small water tank and to provide space for playing cards, it also announced the presence of a lakeside retreat as seen from the water. Such forms had a long history, as seen on nearby Geneva Lake in the tower at Black Point, the estate of Chicago brewer Conrad Seipp built in 1888, and the main pavilion of Ceylon Court, erected from salvaged pieces of an exotic pavilion that was part of the Chicago World's Fair of 1893.[25]

The walkway and tower at Penwern

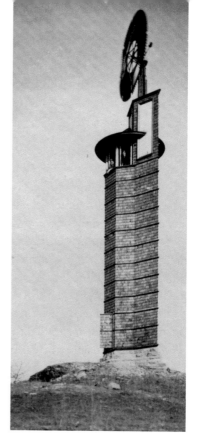

Wright took this photograph of his Romeo and Juliet windmill in Spring Green, Wisconsin.
WHi Image ID 25564

Towers make regular appearances in Wright's early work, beginning with the pair flanking the semicircular boathouse built in 1893 on Lake Mendota, Wisconsin.[26] Wright first approached the problem of designing a freestanding tower in 1897 with the shingled windmill, which he named "Romeo and Juliet," erected on his aunts' property near Spring Green, Wisconsin.[27] In fact, windmills became the main design issue for towers among the Prairie School architects. In 1899, Spencer proposed a covered windmill replete with an observation platform attached to its one-story farmhouse.[28] Although this remained a project, in 1901 Spencer designed a similar enclosed windmill as part of an expansive gardener's lodge constructed in 1901 for the Stevens estate across Delavan Lake from Penwern.[29]

Wright continued to make use of the tower form in his residential architecture, unrelated to windmills, summer homes, or lakeside retreats, in two prominent Oak Park buildings that are decidedly vertical in their orientation: the William Fricke House, designed in late 1901 and constructed the following year; and the William Martin House, designed and constructed in 1903.[30] Finally, when the gate lodge was added to Penwern in 1903, it too was given a tower to enclose a large water tank, designed as a match to but not a copy of the original, lakeside tower.

The Stevens gardener's lodge, complete with windmill
Courtesy of Paul Kruty

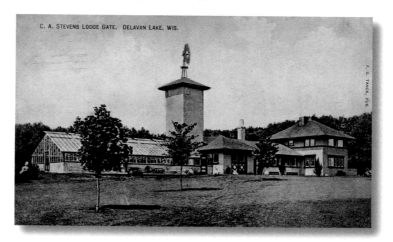

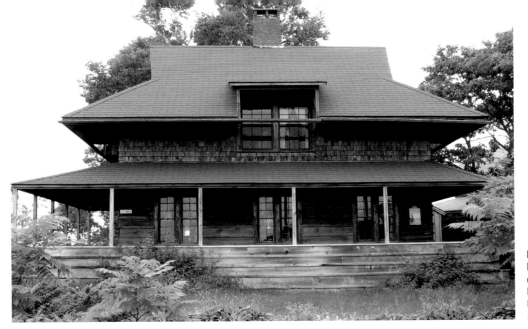

Ella Gould Cottage on Bustins Island, Maine, designed by Walter Burley Griffin for Dwight H. Perkins
Photo by Paul Kruty

◇

My observations here are limited to Penwern's exterior. Its interior, as Mark Hertzberg makes evident in the chapters that follow, is simply unique. The generous rooms, made possible by steel tie-rods embedded in the overhead beams, open on to circular porches and lakeside views.[40] While its massive fireplaces and heavy moldings are appropriate for such a rustic "cabin," the molding forms are also akin to the interior expression of such contemporary works as the Dana House. One element, however, is like no other Wright house anywhere. The architect solved the problem posed by connecting the tower to the house in such a way that the connection did not block the front door by raising the walkway to the second level. On the inside, this required a raised, open hall (marked "balcony" on the plan) that runs between the living and billiard rooms at a half-level, a hallway visible from both spaces. The result is a spatial invention of unexpected richness.

Penwern holds a special place in the Wright canon. It is the most ambitious of the summer homes. As an estate, it possesses an array of buildings unmatched among the works of Wright's first three decades of practice. As a creative work, it joins the Bradley House and the Dana House, two acknowledged masterpieces, as the third grand, experimental house Wright conceived in 1900. Penwern's main house, tower, and boathouse, unified as they are, contain elements previously investigated by Wright, some of which would never appear again; details that were very much on his mind in 1900; and proposals that would bear further investigation.

—*Paul Kruty,*
professor emeritus of architectural history,
University of Illinois, Urbana-Champaign

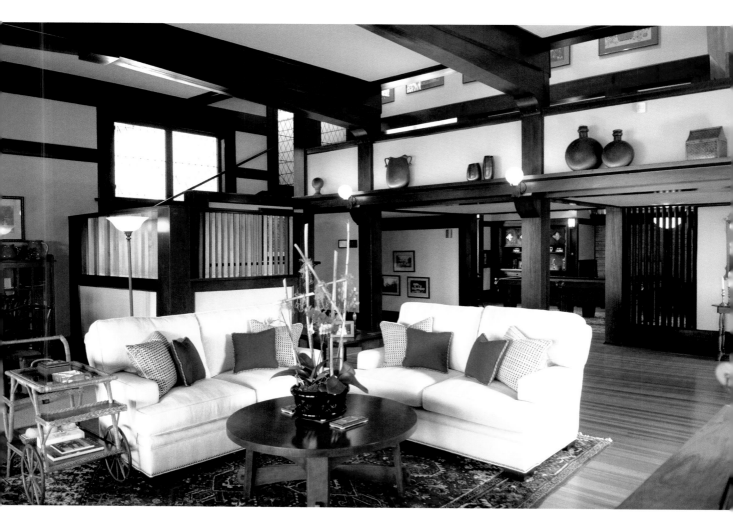

Penwern's second-story hall, viewed from the living room

Notes on the Text and Photographs

The names of two buildings at Penwern have varied. One has been referred to as both the gate lodge and the gatehouse. Frank Lloyd Wright referred to it as the "gate lodge" on his elevation drawings of the structure, and that is the term used in this manuscript. Wright referred to the structure where the horses were kept as a "barn" on an elevation drawing of a design that was not realized and as a "stable" on an elevation drawing of the design that was constructed. I refer to that structure as the "stable" in this manuscript because of the latter drawing and because, although in time it became a garage, its primary original function was as a stable for horses.

Delavan Lake has been referred to as Lake Delavan in various writings about Penwern. Delavan Lake is the correct name.

The cardinal directions used here are as follows: As one faces the estate from the road, the lake is north. The gate lodge is at the south perimeter of the estate.

When costs or prices are given, estimated current dollar values are in parentheses following the original dollar value. Calculations are based on the percentage increase in the Consumer Price Index to 2018 and were done using the calculator at www.measuringworth .com/calculators/uscompare.

Obvious typographical errors in quoted correspondence have been corrected by the author.

Some of the contemporary photographs of Penwern were taken before the side porches were reconstructed in 2015. Therefore, they show straight exterior porch walls (those walls are now curved, as in the original design) and walls that once stood between the side porches and the front porch that have since been removed.

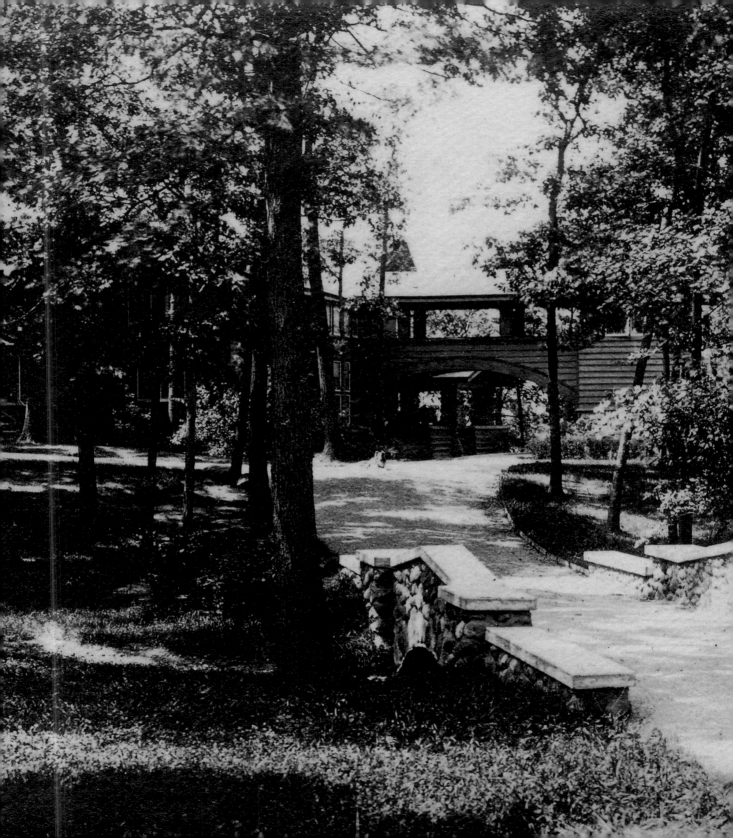

Introduction

❝ *Entertaining at Penwern is always special, very much like a charity event at a museum—only, in this case, we own the museum. This only becomes more [special] as the renovation makes the property more and more authentic—building the boathouse, restoring the gate house, removing the additions, restoring the dining room, restoring the safe room, etc. Our guests have a sense that they're experiencing life as it was at its best with a sense of wonder that the genius of [Frank Lloyd Wright] made it so.* ❞*
—John Major, who with his wife, Sue Major, is the fifth steward of the estate.[1]

While Frank Lloyd Wright is well known for his urban and suburban houses, he had more than forty commissions for summer "cottages" and related buildings, at least half of them built before 1916. Yet these seasonal buildings have often been ignored in the body of critical work about Wright and his architecture. Many of the early summer cottages have a rustic feel and are not as easily recognized as many of his prolific year-round domestic designs.

America had recovered well from an economic depression when five Chicago businessmen commissioned Wright to design summer homes for them on Delavan Lake in southeastern Wisconsin between 1900 and 1905.[2] Their choice of architect ensured that these cottages—four of them as large as

Courtesy of John Hime

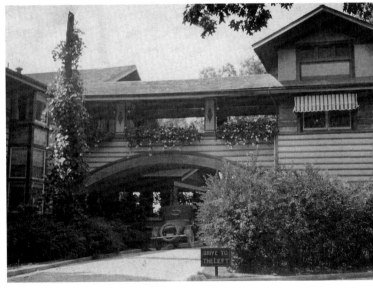

An awning shades one of the tower card room windows in this photo of a 1922 Buick parked at the entrance to the main house.
Courtesy of the Pittsfield (Illinois) Public Library

full-size houses—would have an architectural legacy unlike any others on the lake. Wright's second Delavan Lake client was Fred Bennett Jones, who at age forty-two had seen enough success to commission not just a cottage but a full complement of buildings.

Jones was managing director of the Adams & Westlake Co. of Chicago. The firm, also known as Adlake, manufactured myriad consumer products, including bicycles, brass beds, cameras, and kitchenware, in addition to hardware for steamships, railroads, and streetcars. Adlake's seven-story building occupied a full city block at Orleans and Ohio Streets on Chicago's Near North Side.[3]

Penwern was the most ambitious of Wright's commissions on Delavan Lake. Originally situated on eight acres, it includes four buildings designed between 1900 and 1903.[4] Wright designed the main house and the boathouse in October 1900. The main house was constructed in 1901, followed the next year by the boathouse. The gate lodge and stable were designed in 1903, the gate lodge built that year, and the stable in 1904. Designed for year-round living for the caretaker, the gate lodge had four bedrooms and was centrally heated; Jones slept there when he visited Penwern in the winter. Of the four buildings, only the gate lodge is easily visible from the road.

All four structures at Penwern are two stories. Though they are spread out over the grounds, some are linked by common design elements—primarily arches, dramatic gables, and raised roof ridge lines. Much has been written about Wright's domestic architecture bringing the family together around the hearth or at the dining room table. When he presented his plan for

The driver of a horse-drawn cart pauses in front of the gate lodge. *Courtesy of John Hime*

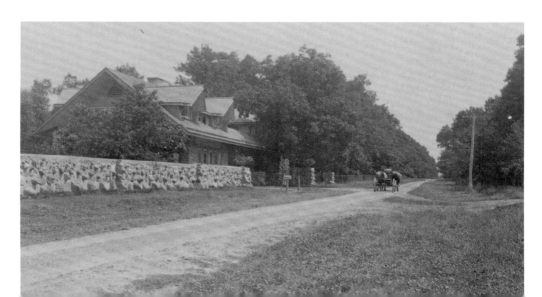

THE MEANING OF *PENWERN*

A plaque displaying the word *Penwern* is set in a fieldstone column in front of the gate lodge, the first building visitors encounter at Fred B. Jones's estate. The origins of the name are murky.

The popular, published conception that *Penwern* is Gaelic for "great house" is wrong on both counts. The word is Welsh, and it does not refer to houses or other structures. It can mean "at the head of the field," "at the head of the alder tree,"[1] or even "end of the wet land."[2] There are several Penwerns or Pen-Y-Werns in Wales, some cottage names and some place names. Their derivation may lie in *Pengwern,* a sixth-century Welsh kingdom near modern-day Shropshire. That name meant either "at the head of the alder swamp" or the head of the Severn River.[3]

Some early newspaper stories about the estate used the spellings "Penwaryn" and "Pennwarryn." The first appeared in 1902, the year after Jones moved into his splendid new house. "F. B. Jones' new home, Pennwaryn, is one of the most cosily artistic places ever conceived by an architect. It is charmingly located upon a knowl [*sic*] having a fine command of the entire lake."[4]

Frank Lloyd Wright was close to his mother, whose parents emigrated from a cottage named Pen-y-wern near Llandysul, Wales. It is possible that Wright took the opportunity of having designed a home for an American client named Jones to honor his mother's family, also named Jones.[5] (However, the suggestion that Fred B. Jones and Wright may have been related is unfounded.)

Georgia Lloyd Jones Snoke, Wright's first cousin twice removed, visited the ancestral family Pen-y-wern cottage in Wales in 2004. She offers this perspective on the possible connection between the two Penwerns:

The young girl who grew up in Penwern lived a life with few options. She was a farmer's daughter, a Unitarian within the small circle of Unitarians that was known to the rest of Wales as "the Black Spot" of heresy. On an adjacent farm a young man with a parallel upbringing cast his eye on the growing girl. It was a surprise to no one when they wed, set up house together, became parents to an increasing brood of hungry children.

Times were hard. Food was scarce. Opportunities were limited. In a faraway land called America it seemed that things might be better—if not for them, then for their children.

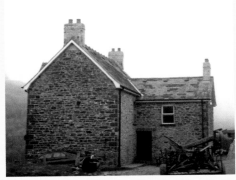

Pen-y-wern cottage in Wales
Courtesy of Kenneth Snoke

Richard was in his mid-forties and they were already parents of seven children, the last a babe in arms, when Richard decided to brave the waves and emigrate to America. It was to be a total break. There would be no return trip. Their good-byes were forever. Their future unknown.

Other siblings had gone before. After a hazardous journey and the loss of one child to diphtheria, Richard's bereaved family and his brother Jenkin were reunited in Wisconsin. A year later, Jenkin died of malaria, leaving

continued

Richard's family distraught and destitute, but in the America they had sought, an America where four more children were born and the family slowly, with great effort, endured, survived, and began in a small way to prosper.

Some 150 years later, on a gray rain-threatened day in Wales, my ankles deep in the muck of a cow path, I looked at the cold stone building before me, the Welsh Penwern of now, and imagined the emotions my great great grandmother "Mallie" must have felt, looking upon her ancestral home for the last time.

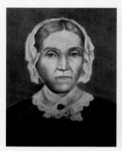

Mallie Jones, Richard Jones
Courtesy of Georgia Snoke and Janny Strickland

What courage it must have taken to leave the world and people she knew—no matter how hard the life—to embark on a journey into the unknown.

The story is told that their last evening at home Mallie went out and gathered flower seedlings. When they settled in Wisconsin, the seeds were planted, and, with each subsequent move, the progeny of those seeds moved with them.

It was from the gentle Mallie that the stories of Wales were imprinted on the children and grandchildren. There were the tales of the two oldest boys, then but small children, sent out to watch the flocks of sheep and protect them from the wolves that prowled the hillsides, and of Richard, the hatmaker, whose production of the tall conical hats worn by Welsh women augmented their meager farming funds.

For the remainder of her life, Mallie spoke only Welsh. She was illiterate in writing—signing her marriage certificate with an "x"—and yet on her deathbed she recited from memory her grandfather's translation of Gray's Elegy.

She, far more than Richard, kept the stream of "cumry" (cousinship) alive in the children's minds—so much so that at least four of them made trips to Wales during their lifetimes.

Why did Frank Lloyd Wright suggest the name of Penwern for a Wisconsin home so elegant, so lavish, so unlike its Welsh predecessor? I can only guess it was to honor his grandmother. He was but a toddler when Mallie died (1870) but throughout his growing years he would have heard her stories, lauded the bravery that brought her to these shores, witnessed the loving, aching sense of loss from those she left behind.

Had Mallie stayed in Wales, insisted on the known over the unknown, fled from the hardships she knew were ahead of her how different would have been the lives of those generations yet to come. Would there, could there have been an architect, Frank Lloyd Wright, without her brave plunge into the future? Instead, her legacy lives on in the lives of her American descendants and in the opportunities her sacrifices provided for those willing to experiment, dream, dare, create anew. I like to think that the name "Penwern," superimposed on an extraordinary American estate, is a bow of homage from a grateful grandson.[6]

NOTES

1. The Welsh translations are from Will Wallis, proprietor of Penwern estate in Cornwall, and from the National Library of Wales, in phone calls and emails to the author in October and November 2013, as well as from the website http://cornwallinfocus.co.uk.

2. John Cullen, email to the author, December 18, 2017.

3. www.historyfiles.co.uk/KingListsBritain/BritainPengwern.htm; Professor Donald Leslie Johnson, email to the author, November 1, 2016.

4. *Delavan Republican*, May 8, 1902.

5. Jack Holzhueter, conversation with the author at Wright's Bernard Schwartz House, Two Rivers, Wisconsin, July 21, 2015.

6. Georgia Lloyd Jones Snoke, email to the author, August 10, 2015.

"A Home in a Prairie Town" in the *Ladies' Home Journal* of February 1901, he wrote about an architectural approach "in keeping with a high ideal of the family life together." Penwern had no such family, for Jones was to be a lifelong bachelor. It is considered to have been built for Jones to entertain his numerous friends, away from the stress and heat of the Chicago summers.

Wright, an architect from the western Chicago suburb of Oak Park, was thirty-three, nine years younger than his client, when Jones hired him. His career and reputation were rising in the Chicago area, where he had already designed several dozen city and suburban houses. Thanks to his impulsively extravagant spending habits, Wright had many creditors to satisfy. He certainly would have welcomed a large commission such as Penwern, both for the fees it would generate and as an affirmation of his talent.

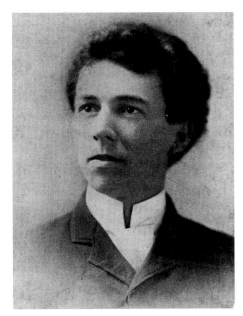

Frank Lloyd Wright shortly after he arrived in Chicago in 1887
WHi Image ID 26558

As an estate, Penwern stands out from most of Wright's residential commissions, though it was not the only estate he designed. (The others include the Avery Coonley Estate in Riverside, Illinois; the Darwin D. Martin complex in Buffalo, New York; Graycliff, the Martin summer home in Derby, New York; and Wright's own home, Taliesin, in Spring Green, Wisconsin. All but Graycliff were year-round residences.) Architect and Wright scholar Patrick J. Mahoney notes that while many of Wright's houses have only two public rooms (a living room and a dining room), Penwern has three: living room, dining room, and billiard room. Penwern also has an impressive living room fireplace, one of the largest he designed. Wright apparently did not refer to Penwern in any of his writings or publications of his drawings. Consider, too, that Penwern preceded those other commissions. In that sense, then, Penwern was a pacesetter.

Wright's architectural style was evolving when he designed the five Delavan Lake seasonal residences within a mile of one another on the lake's south shore. Each has a commanding view of the lake. Though located near one another, they do not share exterior design elements other than wood siding and open porches facing the lake. The dwellings are often referred to as "cottages," but only the Carrie and George Spencer House, completed in 1902, is diminutive enough to be considered a cottage in today's vernacular.

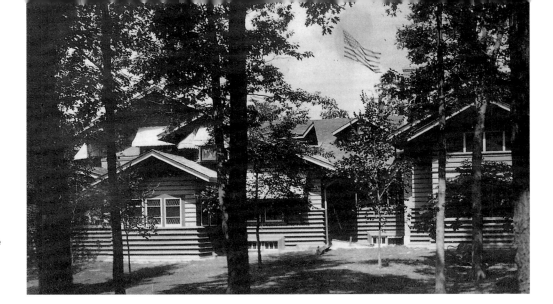

The west addition to the main house obliterated the grace of Wright's thoughtful design.
Courtesy of John Hime

All of Wright's Delavan Lake cottages have been altered, some by their original owners. None of the changes were designed by Wright. Jones had additions to his lake house constructed in 1909 and 1910.[5] Wright, who left for Europe in 1909, clearly had no hand in designing the additions, which were unsympathetic to the design of the house.

RESTORING PENWERN

Modern-day stewards of altered Wright structures must decide not only whether or not to restore the property, but also the period to which it should be restored. Should it reflect how it looked when Wright's client moved in, or how it looked when the client sold it or died?

When Sue and John Major became the fifth stewards of most of Penwern in 1994, the couple committed themselves to restoring the estate to Wright's original design. They acquired the gate lodge in 2001 with the same intent. A significant amount of work would be needed to restore the estate to what it had been when Jones moved in. "Shortly after purchasing the house we became aware that we had the original drawings," John Major says. "We had to renovate the house. The decision was whether in the process we should return it to how it was intended to be or not. To us, to me, that was an easy call. The house was functional [when] we bought it. It was, or could be, an architectural wonder if restored to how it was built."[6]

Substantial as they were, Jones's two additions to the main house would have to be demolished to eliminate changes not intended by Wright. Significant modifications made to the gate lodge in the late 1900s and a second greenhouse built for Jones would have to be removed. The facade of the stable would have to be partially rebuilt. The most daunting challenge would be rebuilding the boathouse, destroyed by arson in 1978. Today those considerable projects have all been realized. As a result, Penwern is both the best known of Wright's Delavan Lake houses and the most authentic.

Sue and John Major, working with their contractor, Bill Orkild, have restored Penwern to the estate Jones and Wright envisioned in 1900–1903.

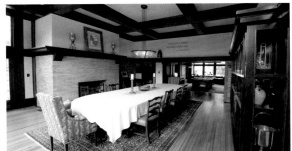

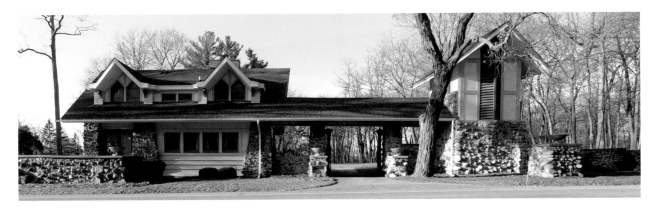

A FINE PLACE TO ENTERTAIN

Each steward has had a unique history at Penwern, and all have enjoyed sharing their lake home with their friends. Typical of the local weekly newspapers of the early 1900s, the social notes of the *Delavan Enterprise* and the *Delavan Republican* were replete with reports of the numerous out-of-town visitors to the lake houses, including Penwern. The roster often included prominent Chicago businessmen. Today's senses of equity and equality were nonexistent as businessmen (never women), all presumably white, tended to their affairs during the day and socialized after work. It is not difficult to imagine Jones and his friends enjoying after-dinner drinks in billowing clouds of cigar smoke at Penwern, as they did at their clubs in Chicago. The gentle lapping of waves against the shoreline at the boathouse would have contrasted with the boisterous sounds emanating from the tower room where the men played cards. The tower room was indeed exclusively for men. They would not have to stray far from their card game when nature called, for built into a wall was a porcelain urinal that drained into a bucket inside the base of the tower.

Besides the tower, Jones had ample room for socializing. In the main house, the billiard room is immediately to the left of the entryway, which looks into both the spacious dining and living rooms. There are three porches with views of the lake. The covered pavilion of the boat-house could be used for entertaining as well.

Penwern comes alive for Fourth of July celebrations today as it must have in 1901, when Jones first welcomed his friends to the lake just a week or two after moving into the house. In that sense, little has changed at Penwern, although guests no longer take a train to get to the great house on South Shore Drive.

John Major considers Wright's vision and design genius as he sits on the front porch on a summer afternoon, gazing at the lake and the boathouse and admiring the sightline. He praises

The social notes columns of the local papers eagerly observed the comings and goings of Jones and his guests.
Delavan Enterprise, *July 2, 1901; Delavan Enterprise, July 10, 1902*

not only Wright, but also the craftsmen who built the estate. "It is still unbelievable that you can figure out the level of this [front porch] floor," he says. "The boathouse is one foot lower. If it was one foot higher, it wouldn't have worked [because the boathouse would have blocked the view of the opposite shore]. There is no room for error. [The boathouse] is huge. If you built it and it was one foot higher, there is nothing you can do about it. . . . When I have just a moment to myself, I sit in the great [living] room . . . and take it in."[7]

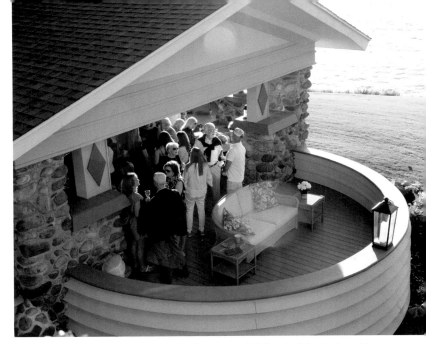

Guests mark the beginning of the summer social season at a July Fourth celebration hosted by the Majors.

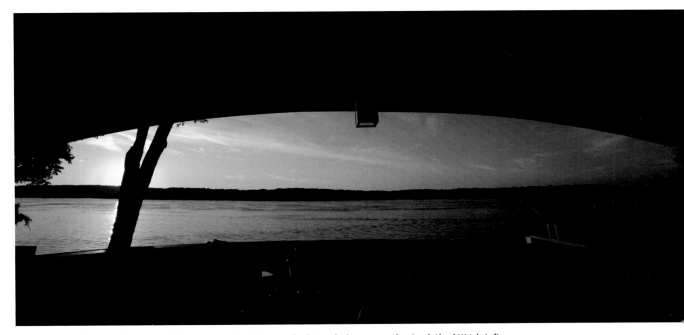

Numerous homes have been built, demolished, or replaced on Delavan Lake during the last century, but Frank Lloyd Wright's five cottages still stand. Fred B. Jones's selection of Wright to design his estate ensured that Penwern would garner both curiosity and accolades, including listings on the National and State Registers of Historic Places. The Majors' renovations ensure its future.

Fred B. Jones

F red B. Jones led a life that likely was remarkably different from the lives of his schoolmates. Nothing in his upbringing in Pittsfield, in rural southwestern Illinois, foretold his later success. He moved to Chicago after high school to take an entry-level job with a major manufacturing company, ultimately becoming a wealthy executive of that same company and a world traveler who would commission a landmark house. To fully understand and appreciate Penwern, it is important to know Jones's story, that of a small-town kid who made good at the turn of the twentieth century.

There are scant contemporary remembrances of him. Some seventy years after he died, Jones was remembered by Dorothy Forster, the daughter of caretakers at Penwern, as elderly and stout, perhaps weighing more than three hundred pounds. He loved riding his horses, which spurred his winter visits to Delavan Lake. There were four bedrooms in the gate lodge, but only two with fireplaces. Jones displaced the caretakers' two daughters from their bedroom when he visited, but they didn't mind a bit, Forster said decades later, because he was friendly and did not put on airs around the house.[1]

Most of what we know of Jones's biography and persona are gleaned from newspaper stories, a contemporary trade journal, and court documents. It is not known if he kept a diary or if he was a prolific letter

Penwern's main house, stable, and boathouse were not visible to Fred B. Jones's guests until they passed through the iron gates of the gate lodge, built in 1903.
Collection of Eric M. O'Malley/Organic Architecture + Design Archives

writer. Other than Forster's casually reported recollections, only two descriptions of his ebullient personality have been found. The *St. Paul* (Minnesota) *Daily Globe* newspaper profiled Jones extensively in 1888 in a column about "commercial travelers," or traveling salesmen.[2] None of the other traveling salesmen mentioned that day merited more than a brief reference to their work. Jones clearly had made a mark for himself in his profession as a salesman, after a modest start as a stock clerk:

> *One of the heavyweights of the profession is Fred B. Jones, representing the Adams & Westlake company of Chicago. He tips the beam at 215 pounds and he appears to increase in avoirdupois each year.*
>
> *For the past thirteen years he has been on the road for the firm which he represents, his specialty being lighting materials and trimmings for [railroad] car interiors, and his jolly face is like a sunbeam in any assemblage.[3] Fred was born in the Sucker state [as Illinois was once known] thirty-one years ago and after leaving school at the age of eighteen, he started out as a commercial traveler, and has proven himself a very successful one. He makes his headquarters in this city, and his territory embraces the great railroad centres, such as Omaha, Denver, Kansas City, St. Louis and Milwaukee, and among railroad magnates he is a universal favorite.*
>
> *In addition to his business qualifications, he is a good story teller, and many an evening that would otherwise prove tedious and dry is whiled away listening to his inexhaustible fund of anecdotes.*

This last observation is fitting for a man who would enjoy hosting his numerous friends at his lake "cottage" in Wisconsin.[4] In addition to Jones's comings and goings listed in the weekly local newspapers, there were brief mentions of him in his hometown Pittsfield newspapers, but never with any adjectives describing him. He was finally described as "genial" in a trade journal in 1910, two years after he retired.[5]

While being "genial" was an indispensable trait for a salesman such as Jones, he appears to be ill at ease in the few known photographs of him, evidently taken when he was in his sixties. He evinces a slight smile in just one of the five, and he did not even pet the collie standing next to him in the only existing photo of him at Penwern. He looks particularly self-conscious posing for a photograph atop a camel in Egypt during a trip around the world in 1924 (see page 10).

Fred B. Jones as an artist captured him in 1888 for a Minnesota newspaper St. Paul *(Minnesota)* Daily Globe, May 12, 1888

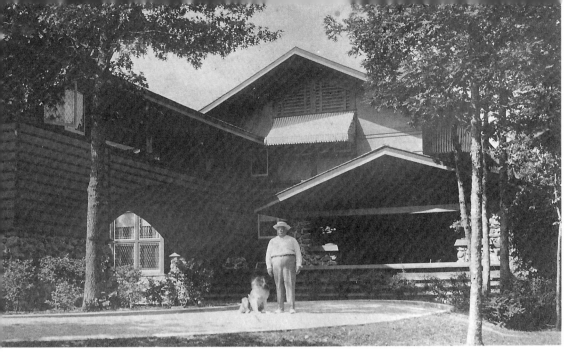

The only known photo of
Jones at Penwern
Courtesy of John Hime

Important locales in the
life of Fred B. Jones
Map by Eric O'Malley

A PIONEER FAMILY

The Jones family had roots in Massachusetts in early colonial
America. Lewis Jones, the American progenitor of the family, is
thought to have emigrated from England around 1640. He was
possibly of Welsh ancestry. Another ancestor, Captain John
Jones, served in the Continental Army and died of smallpox
July 4, 1776. The family moved to Pike County in southwestern
Illinois in 1831. Nathan Jones, grandfather of Fred, founded
the town of Griggsville in Pike County in 1833.

Fred was born January 14, 1858, in Peoria, Illinois, to
George W. and Cecilia Bennett Jones. He had two older broth-
ers: William Jones, who died in 1854 at the age of eighteen
months, and Frank Hatch Jones, born in 1854. George was an
owner of Selby, Jones & Company, a manufacturer of plows and
wheat drills. He had become wealthy buying land in Illinois
and Ohio.[6] The family moved to Pittsfield, the Pike County
seat, in 1859, and George was elected clerk of the county's cir-
cuit court a year later.

The files of the weekly Pittsfield newspapers offer glimpses
of Fred's adolescent years. At age sixteen, he left home to fin-
ish high school in Jerseyville, about sixty miles away. Professor

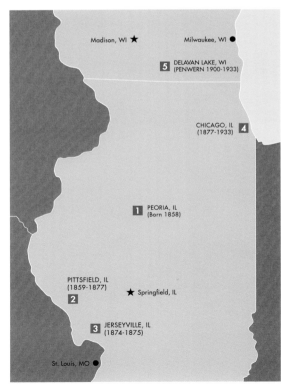

Joshua Pike, a teacher who was highly regarded in Pittsfield, had moved to Jerseyville to become principal of a new school. Frank had studied with Pike at Pittsfield High School, and Fred evidently followed him to Jerseyville. Out-of-county students like Jones paid $12.75 ($270 today) in tuition per seventeen-week term and boarded in furnished rooms with local families for $3.50–$4.50 a week.[7] Fred reported "a flourishing school there this year" during an 1875 visit home.[8] Fred's trip home in May 1909 coincided with a banquet in Pittsfield honoring Pike.[9]

He evidently liked spending time with his father at the Pike County Courthouse. When his father once allowed him to swear in witnesses, Fred was flattered, asking them: "Do you solemnly swear to tell the truth, the 'wholey' truth and nothing but the truth, so help you God?" Because of that, "the nickname 'Holy Jones' hung onto him for a long time."[10] Fred was eighteen when he accidentally dropped a revolver in his father's office and shot himself in the foot. The incident was reported in the *Pike County Democrat*: "Fred was then carted home in an express wagon, and will for a time have a very lame foot."[11] Several months later the *Democrat* reported that he had helped the county sheriff and a deputy transport seven convicted felons to the state prison at Joliet.[12] Some of his fishing trips with friends merited mention in the newspaper as well.

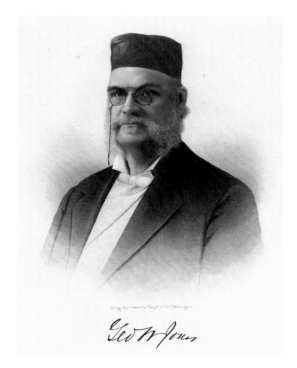

George Jones moved his family from Peoria to Pittsfield, Illinois, in 1859, a year after Fred was born.
In Memorium: Founders and Makers of Illinois, *S. J. Clarke Publishing Company*

George and Frank, and to a much lesser extent, Fred, were active in Democratic Party politics in Pike County, especially in 1876 when they campaigned on behalf of the unsuccessful Samuel J. Tilden–Thomas Hendricks presidential ticket. George and Frank also served on several committees as Pittsfield prepared to mark the nation's centennial on July 4, 1876. (Fred, eighteen at the time, apparently served on none.)

Brothers Fred and Frank followed markedly different paths in their education and careers, but they were very close. Frank, who later would often visit Penwern, went to Yale, where he was a member of the secretive and exclusive Skull and Bones Society; he graduated from law school in Chicago, served as first assistant postmaster general for President Grover Cleveland, and was later secretary of the American Trust and Savings Bank in Chicago. He was twice married and widowed. His first wife, Sarah (Sallie) Bunn, was a member of a prominent Springfield family, reportedly the wealthiest family in Illinois at the time.[13] His second marriage, to Ulysses S. Grant's

daughter, Nellie Grant Sartoris, in 1912, was widely reported in newspapers. By contrast, Fred would remain a bachelor and had no formal education after high school, a college education not being as common then as today.[14] Fred was best man at both of Frank's weddings, but there are no known photographs of either wedding party.

The brothers rarely returned to Pittsfield. One visit was recalled in a newspaper article five years after Fred's death: "Fred and Frank Jones first returned here for a visit in [late May] 1909 after an absence of almost 30 years. On this occasion Fred Jones was recognized by John Heck in the Heck store when they came to call, by his youthful habit of adjusting his shirt cuffs and sleeves at the wrist. Fred had just returned from a trip to South America at that time. Frank Jones made two other visits here."[15] Bone Hudson, a Pittsfield native living in Chicago, took note of the brothers' successful careers in a 1914 letter to the *Pike County Democrat* about three hundred Pike County residents who had moved to Chicago.[16]

The Jones brothers were bibliophiles. Frank predeceased Fred by two years and willed him his library. Fred sometimes signed his name on the inside front cover of his books. His book-plates are illustrated by a caricature of an owl reading a book by the light of a candle and a flame torch. A copy of M. K. Gandhi's *Young India 1919–1922* is signed "F. B. Jones S.S. *Resolute* Jan 19/24"—a reference to Jones's around-the-world journey in 1924.

While their libraries were impressive in size, the brothers were not necessarily well read. Andrew McLean, professor emeritus of English at the University of Wisconsin–Parkside and an antiquarian book dealer, observes that, while such a collection may indeed have reflected the owners' intellectual curiosity, it may also have simply been a statement of wealth.[17]

The library of Frank and Fred Jones, consisting of some 5,000 volumes, reflects many of the changing cultural, political, scientific, social and commercial concerns of 19th century America. The literature of the times deals specifically with various aspects of these changes, especially in the private libraries of financially successful families. A large library was often a status symbol suggesting economic success and cultural sophistication. This library, for example, contains the "complete works" of Emerson, Longfellow, Bret Harte, Henry James, Hawthorne, Ingersoll, Shakespeare, Tolstoy, Balzac,

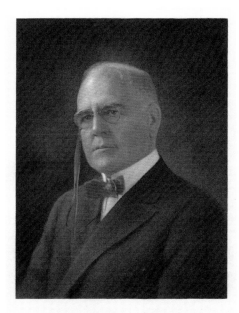

Frank Hatch Jones and his younger brother followed very different career paths, but they remained close.
In Memorium: Founders and Makers of Illinois,
S. J. Clarke Publishing Company

Dickens and others. Many of these sets are limited editions in fine leather bindings. The content … is representative of upper-middle to upper-class readings of the time.[18]

A RAPID CAREER RISE

The weekly *Pike County Democrat* took note when Jones began his career at Adams & Westlake in November 1877: "Our young friend Mr. Fred Jones, younger son of George W. Jones, Esq., is now employed in a hardware house in Chicago, in which and all other lawful undertakings we wish him all success as a most worthy young gentleman."[19] His uncle, J. Howard Jones, lived in Chicago, so Fred knew at least one person in the city.

Jones was nineteen when he started as a stock clerk at Adlake, earning just $6 a week ($145 today). By the time he commissioned Penwern at age forty-two, he would be managing director of the company. He retired around age fifty as vice president and two years later was the company's largest individual stockholder, with holdings worth $400,000 ($10,100,000).[20]

Rail was the prevalent means of intercity transportation, and Adlake enjoyed a robust business, manufacturing hardware products for steamships, railroads, and streetcar companies. The company's important customers included the Pullman Palace Car Company. In addition, Adlake made such diverse products as bicycles, brass beds, cameras, and kitchenware. Jones was also a director of two companies affiliated with Adlake, the Curtain Supply Company and the US Headlight Company. Both firms made equipment for railroad cars and electric railway cars.

The Transcontinental Railroad opened in 1869; its impact on American life and on the nation's economy cannot be understated, particularly when considering Fred B. Jones's future livelihood. As railroads extended their reach across America, facilitating both passenger travel

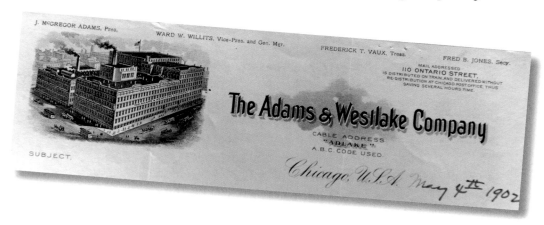

Adams & Westlake's company letterhead from 1902 lists Fred B. Jones as secretary — and Ward W. Willits, another Wright client, as vice president and general manager. *Courtesy of Peter Willits Burnside*

and commercial shipping, the opportunities for Adlake to expand its business as a major supplier to railroads grew exponentially. And as Adlake grew, Jones's opportunities within the company did as well.

An Adlake sales receipt from May 31, 1890, lists a "Jones" as the salesman for transactions with the Metropolitan Street Railway Company of Kansas City, Missouri. In 1915, seven years after he retired, Jones traveled to Savannah, Georgia, on a "motor tour of the South in search of a warmer climate" and, in an interview with a local newspaper, recalled coming there on business twenty years earlier. "In those days," he explained, ". . . the railroad people did not have much of an idea as to the use of a switch light or a tail light. I remember one time when I installed a set of tail lamps on a train in this state, that they were raked off while passing through the yards. It was because the tracks were built too close together."[21]

He was still listed as a traveling salesman in the 1892 Chicago city directory, a "clerk" a year later, and managing director between 1894 and 1900. He represented Adlake at the New York Cycle Show in February 1897. The "Great Show of Cycles" merited more than two full pages of promotional stories in *The New York Times*, followed by a full page of manufacturers' advertisements.[22] Adlake trumpeted that their bicycle wheels—even on their tandem and triplet models—were "ornamented and striped in gold leaf."

Jones was undoubtedly wealthy by age forty-two, when he commissioned Frank Lloyd Wright to design his estate. By 1901, a year later, he had been promoted to secretary of the company. He was named vice president in 1905, serving in that position until he retired in 1908. Jones was a socially active bachelor; clubs were significant measures of men's business and social status, and he belonged to at least eleven clubs and associations in Chicago and Delavan. Some were for sport and socializing, such as the Exmoor and Old Elm golf clubs in Highland Park and the Delavan Lake Yacht Club. Others, such as The Chicago Club and the (Chicago) Mid-Day Club, were renowned for facilitating professional networking.

One of the clubs most important to Fred was the Chicago Athletic Association on South Michigan Avenue.[23] More than just a member, he lived there for a time and served briefly on the board of directors, as chair of the billiards committee, and on the entertainment, house, and membership committees. The club likely set the scene for bachelor social life at Penwern. Sitting today in the dimly lit second-floor lounge (richly paneled in oak), near the north fireplace with its wonderful mahogany bas relief of young men playing football, it is easy to imagine Jones and his fellow club members arriving, perhaps at one time by horse-drawn cab, crossing the mosaic floor in the entryway, climbing the thirty steps to what was certainly a smoke-filled lounge, and enjoying drinks before and after billiards matches in the adjoining game room. No women

The Chicago Athletic Association is now a boutique hotel, but many trappings from its heyday as a men's club remain.

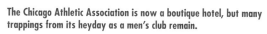

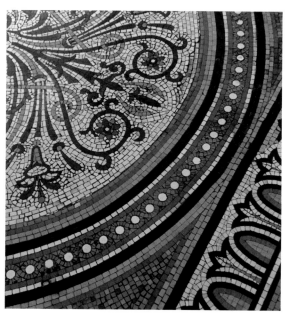

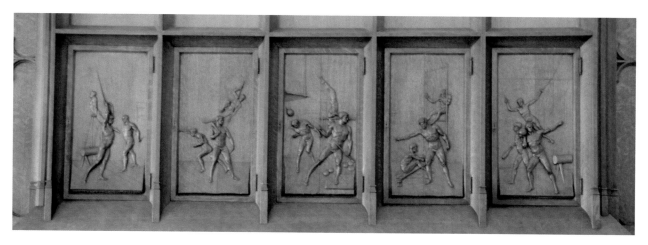

were allowed in the club until the 1970s, so the men's social banter would have been loose and unguarded. Jones might have looked for his mail in one of the brass mailboxes that are still set in a wall between the lobby and the swimming pool.

A ZEST FOR TRAVEL

Fred Jones was a seasoned world traveler. A vacation abroad meant packing and traveling with bulky steamer trunks and required considerable planning. After all, passage to or from Europe took at least a week. With overseas travel possible only by steamship, Jones would have first journeyed for several days by rail to his coastal city of embarkation. He would have likely used fixtures manufactured by his own company on board both trains and ships.

Ocean voyages were significant enough to merit daily shipping news columns in *The New York Times* and major newspapers in other port cities. Short articles listed arriving and departing passengers, but Jones seems never to have been accorded such attention. A ship's departure saw throngs coming to the pier to wish "Bon voyage!" to travelers who waved back from the decks of their ocean liner or cruise ship.

Jones was twenty-eight when he made his first documented travel abroad, in 1886, sailing between Liverpool, England, and Queenstown, Ireland, on the Cunard Line's *Servia*. Ten years later he traveled to Europe for two months. "Fred B. Jones of Chicago, son of Hon. and Mrs. George W. Jones of this city, sails to-day from New York for Europe on a trip of recreation and pleasure. Mr. Jones will spend some two months on the continent."[24] His was one of three steamships sailing from New York to Europe that day, according to *The New York Times*.

Jones was unable to attend his mother's funeral after she died suddenly after a fall at home in Springfield in October 1899. At the time of her death, he was at sea between Hong Kong and Manila on a three-month trip to Asia that included a visit to Japan. He brought home two large, leather-bound volumes of photographs, some hand tinted.

Jones sometimes took winter cruises south. He listed his occupation as "Capitalist" on his 1913 passport and described himself as being 5 feet 9½ inches tall, with a broad and high forehead, a short and broad nose, blue eyes, a small mouth, a full chin, gray hair, light complexion, and a full face. Two years later, instead of a trip to Mexico, Central America, or the Caribbean, Jones "spent the past winter motoring," including the stop in Savannah.[25] The *Savannah Morning News* quoted his gracious assessment of the state's highways: "Georgia's roads are among the best I have traveled over in some time, and I am sure that in a short time, with the work now going on, the state will have one of the best chains of automobile roads in the country."[26]

Fred's two most intriguing trips were with the widowed Dora Mortimer. There are no existing cabin records to indicate whether he and Mrs. Mortimer shared a cabin or traveled in the same cabin class either time. They sailed to Asia in 1922. The leg from Yokohama, Japan, to Honolulu on the return journey on the SS *President Wilson* took a week. The affidavit on Jones's 1922 passport application was signed by Charles Rosen, a tailor in the Chicago Loop, who certified that he had known Jones for more than twenty years.

In 1924, Fred and Dora traveled around the world. Four albums of photographs, probably shot by a ship's photographer, recorded the voyage, including the passage of the SS *Resolute* through the Panama Canal. One image shows the pair on camels at the pyramids and the Great Sphinx of Giza. Two other photographs show Jones in a wheelchair on the ship; he broke his leg while in Egypt.[27] Jones's last known trip abroad was to the Bahamas in March 1925, again with Mrs. Mortimer.

Dora Mortimer looks apprehensive, and Fred B. Jones dour, in this photo taken at the Giza pyramid complex in 1924. *Courtesy of Sue and John Major*

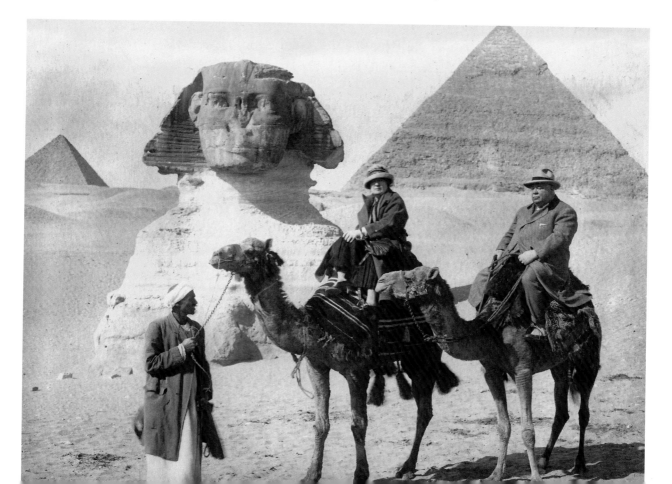

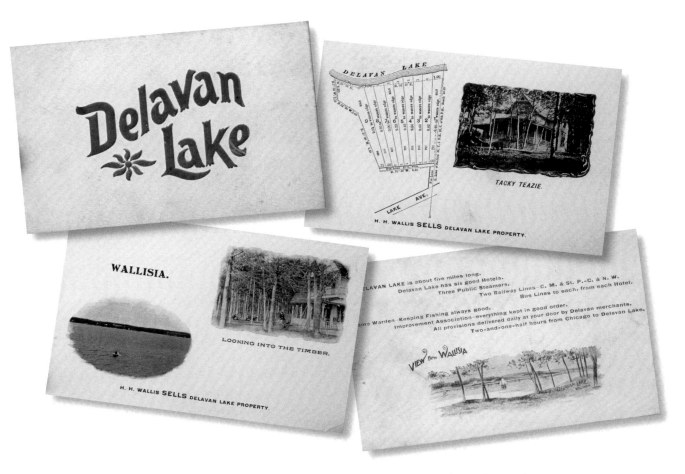

Marion Livingston shed further light on the ties between Wallis and Wright in a letter to Thomas Eyerman of Chicago in 1992. "I talked with my cousin, Arthur Johnson the other day," she wrote, "& he told us that a number of years ago he contemplated building 'spec' houses at Delavan & went to see Wright about it. . . . Wright was most cordial. . . . We both agreed that Wright had probably drawn the other things I gave you himself, as he and Henry Wallis were such close friends (like brothers as Mrs. Wallis said) & whenever he sold a lot, Mr. Wright would dash off little mementos for him as [later] they were next door neighbors in Oak Park."[43]

Jones acquired the land for Penwern in nine real estate transactions between 1900 and 1904, seven of them with Henry and Minnie Wallis. The pieces of the puzzle of what brought Jones and Wright together fit neatly if Ward Willits impressed on Jones the advantages of Delavan Lake and Wallis subsequently recommended the architect to Jones.

Wallis's real estate sales brochure presented an idyllic view of a resort community only "two-and-one-half hours" from Chicago. *Courtesy of Sue and John Major*

Chicago Athletic Association

There is another possible scenario that brought Jones to Delavan Lake; however, it is less certain than the Willits connection. Jones was a member and former director of the important and influential Chicago Athletic Association. Many of his future guests at Penwern were members of the same club. A cover story in a 1911 issue of *The Cherry Circle*, the club magazine, was devoted to the Delavan Lake summer homes of some fifteen club members.[44] Two of them, Louis P. Sutter and Charles A. Stevens, bought property on the lake, possibly before Jones.[45] It is unknown whether either man had any influence on Jones's decision to build on the lake.[46]

VISITORS TO PENWERN

Summer life at Penwern was lively, with a constant stream of visitors from the city. Their comings and goings, particularly between Memorial Day and Labor Day, were chronicled in Delavan's two weekly newspapers. Even the annual opening and closing of summer homes, including a housekeeper's arrival for the season, were documented in print. While Wright designed four other summer "cottages" on Delavan Lake between 1900 and 1905, none of them garnered as much attention in the weekly social notes as Penwern.

Jones's many male guests, often described as "bachelors" in the newspaper social notes, included other leading Chicago businessmen.[47] Some of them also received occasional mention in Chicago's daily newspapers. They played cards in what Wright called the Pavilion, the tower of the main house. An inventory of Penwern taken after Jones's death listed the contents of the card room as including one 51-inch round card table, one lot of poker chips, six dark oak cane-seat armchairs, and thirteen miscellaneous pictures and cartoons.

The lake itself was, of course, another attraction for Jones and his guests. Sailing was a popular activity. The *Delavan Republican* reported on July 4, 1901, that the new half-rater class sailboat Jones bought the week before was entered in the holiday regatta; it is not known whether Jones was at the helm or had hired a captain and crew for his boat.

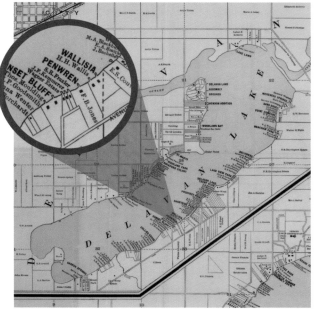

This 1907 map showing properties around Delavan Lake spelled the name of Jones's estate as "PENWREN."
WHi Image ID 97636

A news item in August 1905 about several couples and single men who were entertained at Penwern is almost lost in the dozens of lines of type that reported social activities on the lake. It is significant, however, because one of the couples was "Mr. and Mrs. H. R. Mortimer."[48] One of the great mysteries about Jones's life is the nature of his relationship with his later travel companion, Dora Rowena LaSuer Mortimer, after her husband, Henry, died sometime before 1910.

FRED B. JONES AND DORA MORTIMER

Jones had an enigmatic thirty-year relationship with Mrs. Mortimer (as she was known even long after her husband's death), one of the few known female guests at Penwern. The two were close, but it has proven impossible to definitively discern the nature of their relationship.

In the 1900 census, Dora Rowena LaSuer, who was thirteen years younger than Jones, was listed as a single woman. There is no known record of her marriage, but she and Henry Reuben Mortimer were guests at Penwern in the summer of 1905.[49] She was widowed by the time of the 1910 census.

Jones and Mrs. Mortimer sailed together in 1922 on the SS *President Wilson* to visit Japan, China, Hong Kong, Manchuria, and Korea. The mailing address used on her passport application was "c/o Mr. Fred B. Jones, Delavan, Wisc." When they returned from Yokohama to Honolulu on the SS *President Lincoln*, their addresses were listed as the same. Despite their many travels together, the only known photos of them together were taken on their 1924 trip around the world (see page 10).

Fred B. Jones (seated in the foreground wearing a pith helmet) and Dora Mortimer (at far left, second row from the top, in a dark dress) join their fellow passengers on board the SS *Resolute* during their 1924 trip around the world. *Courtesy of Sue and John Major*

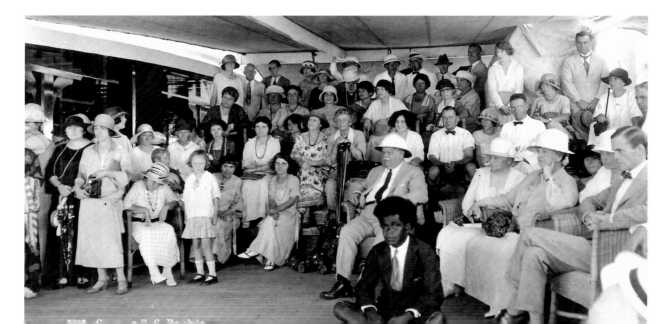

There are just two other known photos of Mrs. Mortimer. The first is with her 1922 pass-port application, which was witnessed by a manager of the fur department of the Chicago department store Marshall Field's. "As an employee and Manager of the Fur Department in Marshall Field & Co.," attested George K. Hill in his affidavit, "I have been in close touch with Dora R. Mortimer for many years, and in the course of conversations she has spoken of her birthplace and date of birth on numerous occasions." Was she an employee there at the time? Or simply a good customer? She requested that the passport be mailed to her at Penwern. The second photo, from the early 1930s, shows her in a housedress and holding a potato that she seems ready to peel.

Jones and Mrs. Mortimer lived on the same floor at the Parkway Hotel at 2100 Lincoln Park West in Chicago, which was Jones's primary residence from the late 1920s until his death in 1933. He lived in a $400-per-month ($7,570) suite of apartments when he died, including a $50 apartment for Irma Dalzell, his cook. Mrs. Mortimer lived in a $125-per-month apartment at the opposite end of the seventh floor; she remained at the Parkway until her death in 1946.

A WEALTHY AND CHARITABLE MAN

Architectural historian Leonard K. Eaton contrasted Wright's clients between 1890 and 1910 with those of the architect Howard Van Doren Shaw. Wright's clients at the time were self-made men, Eaton wrote, while Shaw's clients tended to have been born into wealth.[50] Although Jones's father had wealth, his own lowly starting positions at Adlake before becoming an executive sug-gest that he earned his wealth, rather than inheriting it.

Jones was seventy-five when he died of heart disease and bronchopneumonia on April 9, 1933, at Passavant Hospital in Chicago. He had been under a doctor's care at home before being hospitalized for several weeks. His death merited a story, illustrated with his portrait, in the *Chicago Daily Tribune*.[51] Jones had stipulated that he was to be buried in the family plot in Oak Ridge Cemetery in Springfield, under a marker "similar in style and type as the grave of my brother" (Frank Jones had died on October 2, 1931). Fred's headstone cost $175 ($3,310), his bronze engraved casket, $2,750 ($52,000).

Near the end of his 1932 will, which outlined numerous charitable gifts, Jones stipulated, "In carrying out these purposes it is my desire that the aid, assistance and comfort which this fund is to serve shall be as diversified as possible and yield the greatest good to the largest number, and that careful supervision be had of changes of the condition of the beneficiaries from time to time, and the assistance given be not carried beyond a point that seems reasonable, considering the fact that the fund is limited and its application needed in many places."

He had invested well. His estate was valued at $750,000 ($14,200,000) when he died.[52] Penwern was appraised at $50,000 ($946,000). The assessed value, for tax purposes, was $35,000 ($662,000). Yet Jones's detailed will made no provisions for Penwern.

His largest bequests to charities were $50,000 each, to the Home for Destitute Crippled Children, the Chicago Home of the Friendless, Children's Memorial Hospital, the Chicago Home for Incurables, the (Chicago) Old Peoples Home, and the Salvation Army of Illinois. Another $50,000 was left in trust at the Continental Illinois Bank and Trust for the Chicago Community Trust. In addition, the net interest of any money in his estate not specifically designated as a gift was to be paid in quarterly installments to the Chicago Community Trust,

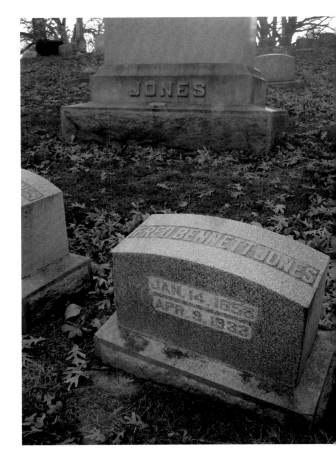

to be paid and distributed through appropriate and responsible channels toward the purchase and distribution of milk, food, ice and for general family relief to deserving poor of the City of Chicago, Illinois. It is not my wish that these distributions be made to institutions devoting themselves to the care of their inmates, but are to be applied to the relief of persons not inmates of any institutions, being worthy families in unfortunate circumstances, particularly those having young children requiring proper nourishment and comfort which, by reason of their position in life, they are not able to have or enjoy.

The trust's Fred B. Jones Special Fund continues to aid members of Jones's adopted hometown. "According to Mr. Jones's intent, the fund is to be used for the relief of the poor, with a special focus on children and families. In order to honor that intent, our staff uses poverty data to understand the greatest regional needs. Currently the fund's grant-making prioritizes services for domestic violence victims and for the homeless," explains Kate Allgeier, content director of the trust.[53] Just since 1990, the fund has awarded grants totaling $4.1 million.[54]

Jones's grave is in a family plot on a hillside not far from President Abraham Lincoln's tomb in Oak Ridge Cemetery in Springfield, Illinois.

Jones also set aside $2,000 ($37,800) for Ivan Erickson, his chauffeur, and $1,000 each for Irma Dalzell, his cook, and Carl Nelson, his gardener and caretaker. He left $1,000 each to a dozen employees of Adlake. His stock in the company was to be offered to shareholders if the company did not wish to buy it back.

Jones left money to fourteen cousins and relatives in six states. He intentionally excluded some relatives, including one who was married but had an affair with his secretary.[55] "I am mindful of the fact that I have not remembered a number of my cousins and other relatives in this Will," he acknowledged. "This circumstance is not an oversight or inadvertence on my part, but it is in accordance with my desire to dispose of my estate and property in the manner indicated in this Will."

Controversy clouded Jones's will because of his generous bequests to the widowed Mrs. Mortimer; he left her more than mere tokens of a friendship:

I give and bequeath to Mrs. Dora Mortimer the diamond ring which I am wearing, also all the contents of my apartment in the Parkway Hotel, Chicago, Illinois, and at my country home at Delavan Lake, Wisconsin, used in and about or in connection with said places, including household furniture and housekeeping articles and all supplies, plate, pictures and linen, also my personal effects, whether of use or adornment, as well as rugs, bric-a-brac, china, glassware and works of art. This bequest, however, is not to include my books and my grandfather's clock otherwise disposed of. Neither is it to include the remainder of my jewelry, which jewelry I wish to have sold by my Executor for the benefit of my estate.

Substantial files in the archives of Cook County Probate Court track the lengthy lawsuit contesting the provisions of Fred B. Jones's will. The plaintiffs asserted that Dora Mortimer exerted undue influence on Jones when he drafted the document.

He also left Mrs. Mortimer a $100,000 trust fund ($1,890,000) administered by the Continental Illinois Bank.[56]

Five cousins of Jones who were heirs-at-law, but not beneficiaries, filed a claim against the estate in Cook County Probate Court in July 1934. No known facts prove or disprove their assertions. They alleged that Jones was suffering from "chronic aortitis, chronic endocarditis, arterio sclerosis, dementia paralytica, general paresis, and softening of the brain" when he signed his will in 1932, eleven months before he died. They added that he was "of unsound mind and memory" and "so mentally and physically infirm that he was wholly lacking in testamentary capacity."

The lawsuit further alleged that Dora Mortimer, "a woman of great strength of body, mind and will, who for many years was the companion of the said Fred B. Jones," and William P. Kopf, a bank officer and "adviser" to Jones in his business affairs, exerted such influence on him that the will represented their wishes, not his.

An amended complaint filed in February was more pointed in its allegations and unsubstantiated characterizations of the relationship between Jones and Mrs. Mortimer:

> *. . . the said Fred B. Jones was unmarried and upwards of seventy years of age and his mind, memory and physical condition were impaired; that Defendant Dora Mortimer. . . is not . . . rightfully entitled to share in his estate; that said Dora Mortimer for more than ten years . . . was mistress, companion and housekeeper of said deceased . . . travelled abroad with said deceased as his cousin though not related to him . . . made her home with said deceased for many years . . . except for household servants, was the only person living with said deceased . . . was possessed of great strength of body, mind and will and had intimate knowledge of the financial affairs of said deceased . . . that said Dora Mortimer dominated the said deceased and on occasions refused various persons an opportunity to discuss business or social matters with him, and on occasions prevented the deceased from social and business contacts with others.*

The case file is extensive, so there were undoubtedly steep and mounting legal fees for the plaintiffs and the beneficiaries. That would have been an incentive for them to settle rather than go through with a jury trial, as originally demanded by the plaintiff cousins, who shared a settlement of $75,000 (equivalent to $1.3 million today, or about $260,000 each) in December 1936. The trust for Mrs. Mortimer would contribute 42 percent of the $75,000, and the remaining 58 percent would be paid by the various charities named in the will.

Dorothy Forster, whose parents worked for Jones and lived in the gate lodge from 1921 to 1924, recalled in 2001 that Mrs. Mortimer "ran the big house" in the summer season and traveled with him.[57] Was Dora Jones's housekeeper as well as his traveling companion? Were they simply two people who enjoyed each other's company? Were they romantic companions after she was widowed? Or, as some have speculated because of the predominance of male visitors to Penwern, was she a female friend who provided social acceptability to a man who may have been gay?

Historian Jack Holzhueter believes Dora Mortimer would not have sailed around the world with Jones if she was merely his housekeeper. "A man of his station" would have traveled with a valet if he wanted a servant on a voyage of that sort. He elaborates, "You have people who travel

together who do not have sex. They are just close friends. You can safely call them companions without intimating a sexual relationship."[58]

When Mrs. Mortimer died of a cerebral hemorrhage in 1946, she was buried in her family's plot in Plano, Illinois, not in the Jones family plot in Springfield. Her "usual occupation" was listed as "housewife" on her death certificate.

REMEMBERING PITTSFIELD

Although Jones rarely visited Pittsfield, he did not forget his hometown. He left his and brother Frank's five thousand books to the Pittsfield Public Library, as well as $25,000 ($473,000) to build an addition to the 1907 Carnegie building to house the collection.

The donation included a grandfather clock that their ancestor Lewis Jones had brought from England. An article in the *Pike County Democrat* opined, "It was a noble and thoughtful act to provide such for the little town which knew him when he and his brother, Frank, were youngsters in Pittsfield. It is an example of the feeling they had for Pittsfield and their old friends here, they did not forget them even though they went far away and secured considerable wealth."[59]

A handsome wood arch divides the annex from the original Carnegie Library. A plaque reads, "This annex erected 1938 with funds bequeathed by Fred B. Jones is dedicated to his memory." An arched niche on the opposite wall houses the grandfather clock and an American flag. A portrait of Jones is on an adjoining wall.

Jones had corresponded with the Pike County Historical Society a year before he died about building a museum for the society. The plans were unrealized.[60] Also unrealized were plans for a Saint Cecilia Memorial Hospital in Delavan, honoring his mother. Planning for the hospital, including an architect's sketch,

A portrait of Fred B. Jones, a family heirloom grandfather clock, and a plaque mark the entrance to the annex funded by Jones's bequest to the Pittsfield Public Library. Many of the books he donated are now in storage, replaced by more contemporary volumes on the shelves of the annex.

began in December 1928 and ended in August 1930 over a dispute with the board of the prospective hospital about Jones's promised financial contributions.

There is no evidence of any negative impact of the Great Depression on Jones, save, perhaps, for funding for the hospital. It was initially thought that a fund would generate $10,000 annually for the hospital. Jones later termed that a "mistake" and said it would generate only $5,000 annually.[61] While he had pledged significant financial support, he was unwilling to put his pledges in writing, which spelled the end of the project.

Clari Dees, genealogy and reference librarian at the Pittsfield Public Library, reflects on Jones's life and relationship with his brother. "I've often thought that it must have been hard to be Frank's brother. From everything I've read, I think Fred and Frank stayed close all their lives, but I also think it would take a great deal of character to be the younger brother of such a man. Frank was the one who was mentioned in the local newspaper over and over again for his collegiate accomplishments and then his political career where he moved in such exalted circles as to rub shoulders with people such as President Grant's family. Poor Fred had to shoot himself in the foot to make the paper. But for all he was the quieter brother—at least in terms of leaving a mark in the newspapers—he sure left a legacy for Pike County."[62]

Though he may have been the "quieter" of the Jones brothers, Fred B. Jones built Penwern to share with others, not just to enjoy by himself. Thus began the estate's enduring legacy common among all its subsequent stewards, a tradition of welcoming friends to enjoy time on the shores of Delavan Lake.

A weathervane featuring Jones's initials once stood atop the stable roof. Today it adorns the living room of the main house. A replica was commissioned for the stable roof in 2018.

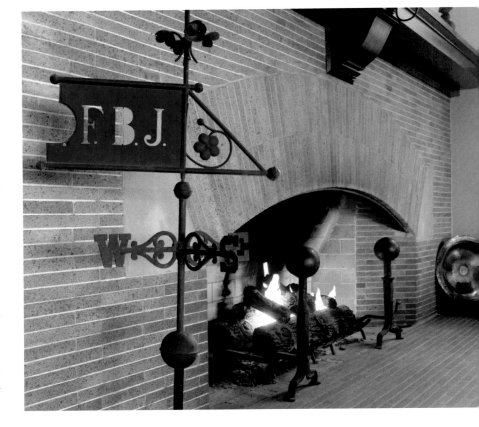

A PENWERN ALBUM

First-person accounts of life at Penwern while Fred B. Jones was alive are rare. But if indeed a picture is worth a thousand words, we have 25,000 words about life at Penwern, thanks to an album of photographs taken in the 1930s. The photographs provide glimpses into the lives of Gerda Johnson Nelson and her husband, Carl Nelson, who became caretakers of the estate in 1931. The album is owned by Betty Schacht, one of the Nelsons' granddaughters.

There is a seasonal variety in the photos: people are seen in bathing suits, on horseback, and ice skating on the lake. The pictures capture the Nelsons' family and friends enjoying Penwern; only a few show the Nelsons themselves. Jones is in none of the photos; they are thought to have been taken after he died.

The photographs are evidence that the caretakers and their visitors enjoyed Penwern's grounds just as Jones and his friends did, just as the subsequent owners did, just as the Majors as their friends do today. And that, arguably, is what Penwern has always been about.

Betty Schacht's grandparents, Gerda Johnson Nelson and Carl Nelson, moved into the gate lodge when they became caretakers of the estate in 1931.

Gerda Nelson's brother-in-law Hagen Hagenbarth, his daughter Lorraine, and Betty's aunt, Helen (Nelson) Carlson, pose on the boulder bridge leading to the main house.

Helen Carlson at the entrance to the gate lodge

An unidentified friend of Helen Carlson's strikes a jaunty pose near the original gate lodge greenhouse. Note the open windows near the top of the greenhouse.

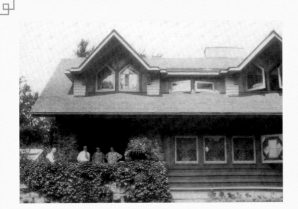

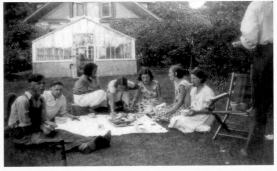

The greenhouse that Fred B. Jones added to the west end of the gate lodge is the backdrop for a Nelson family picnic.

The man at left in this photo of the gate lodge is thought to be Carl Johnson, Gerda Nelson's brother. The other three people are unidentified in the album. Frank Lloyd Wright's preference for casement windows is evident.

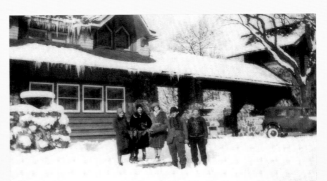

These unidentified horseback riders are thought to have been neighbors of Penwern.

Helen Hagenbarth, Gerda Nelson, Helen Carlson, Hagen Hagenbarth, and "Uncle Norman" prove that winter, too, has its pleasures at Penwern.

Bernice Vollman (Betty Schacht's mother), Helen Hagenbarth, Lorraine Hagenbarth, and Helen Carlson mug for a photographer near the west greenhouse.

All photographs courtesy of Betty Schacht

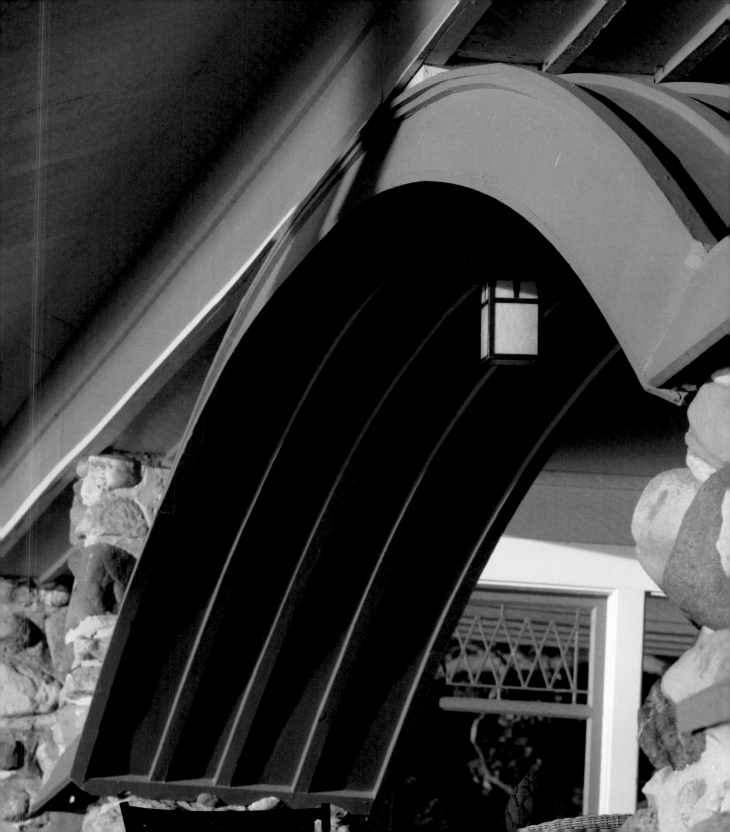

Penwern's Architecture

<div style="text-align: right">2</div>

Questions about Penwern and Fred B. Jones's relationship with Frank Lloyd Wright beg for answers: What manner of building did Jones wish Wright to create for him? How did Jones express his wishes for a "summer residence" to Wright?[1] Was Wright the first or the only architect he sought? Did he ask only for a summer house, or did he present a detailed program for an estate to his architect? Jones and his contractor, Tunis Moore, signed some of the drawings. Was Penwern, as built, the initial design Wright presented to his client? If not, how did the design evolve? How often did the client and his chosen architect consult or exchange correspondence during design and construction? Did Jones readily accept his architect's vision, or did they spar? Historian Jack Holzhueter, who has written about Wright's work in Wisconsin, believes it was an agreeable relationship: "He bought Wright's design. I don't think the estate would have been finished the way it was finished if they had quibbled. Wright would have walked away."[2]

The turn of the twentieth century, when Penwern was conceived, marked a lucrative awakening for Chicago's architects after a lengthy economic depression. "Activities at The Studio in Oak Park were in top gear . . . commissions began pouring into The Studio," wrote Grant

On Penwern's front porch, a dramatic 28-foot-long wood arch marks the transition from sheltered space to the outdoors. The ends of the arch were cut to fit around the boulders at the base.

Carpenter Manson, one of Wright's early biographers.[3] There is no surviving correspondence to shed light on how Jones and Wright met or to illuminate how they worked together on Jones's expansive commission. Architect and client probably conferred at Wright's downtown Chicago office, which would have been more convenient for Jones than traveling to Wright's Oak Park studio, but the designs were executed in Oak Park.

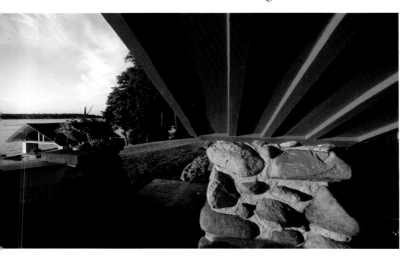

Wright often exceeded his clients' budgets: was that the case with Penwern? And, did Wright ever see Penwern? Only one visit by Wright to Delavan Lake is documented, on August 28, 1905, when he was "making plans for A. P. Johnson's new residence," the last of his five homes on the lake.[4] It is quite likely that Wright would have visited Jones and Penwern at that time, given the proximity of the two houses. Did Wright experience the topography of the property, or had he been sent a topographical survey? On one hand, as John Major observes, the sightline from the front porch of the Jones house past the boathouse

Afternoon light accents the west side of the boathouse, left, and the boulders on the front porch, right.

The stable was designed as a functional service building, but it is no less elegant than the other structures at Penwern. Frank Lloyd Wright gave it the same raised roof ridge lines as the main house and the boathouse.

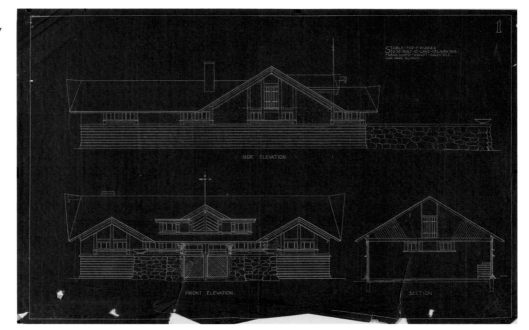

to the opposite shore is perfect.[5] On the other hand, the drawings for the stable do not take into account the sloping site at Penwern. The floor of the stable had to be cut into the south end of the stable site. Wright's elevation drawings of the stable show a structure set on a flat site.[6]

Penwern estate was designed and constructed over four years. The first-floor plan for the house and the boathouse drawings are dated October 1900. According to newspaper accounts, the house was completed by late June 1901, the boathouse by spring 1902.[7] The gate lodge was constructed in 1903. An unrealized design proposal for the stable is dated March 24, 1903; a second design was built the next year.

Wright's two Prairie-style homes, the neighboring B. Harley Bradley and Warren Hickox Houses in Kankakee, Illinois, also designed in 1900, were well under construction when he designed Penwern's main house and boathouse.[8] Penwern is best understood knowing that Wright's architectural style was still evolving in the autumn of 1900. So it is perhaps not unexpected that the exterior of the main house does not reflect the same elements of the Prairie style as Bradley and Hickox.

Just as there is no surviving Wright correspondence about Penwern, there is no known archive of Jones's personal papers—but there are seventeen drawings of Penwern in the Wright archives. Many are utilitarian construction drawings or working drawings. None are handsome presentation drawings made to impress the client. It is not known who in Wright's Oak Park studio delineated them. While some archival drawings have pencil notations in Wright's familiar

Although the greenhouse adjacent to the gate lodge water tower may have been a commercially built structure, it was an integral part of Wright's design for the gate lodge.

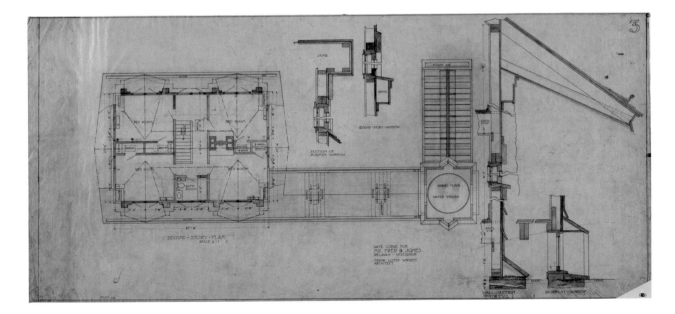

cursive hand, it was a draftsman who made working drawings from Wright's original conceptual sketches.[9] Similarly, it was the practice for others in the studio, not Wright, to make presentation drawings for clients.[10] There are drawings of the east and west sides of the main house; the more dramatic north and south elevations are noticeably absent. Nor is there a site plan.[11]

The absence of presentation drawings for Penwern in Wright's archive is puzzling. It does not seem likely that the drawings for Jones were kept in separate places so that some, and not others, would be reduced to ashes in either of the two fires at Taliesin, Wright's home after 1911. A more likely explanation is found in Wright's discourse about his circa 1905–1906 drawings for Unity Temple in Oak Park. In *An Autobiography: Frank Lloyd Wright*, the architect stated,

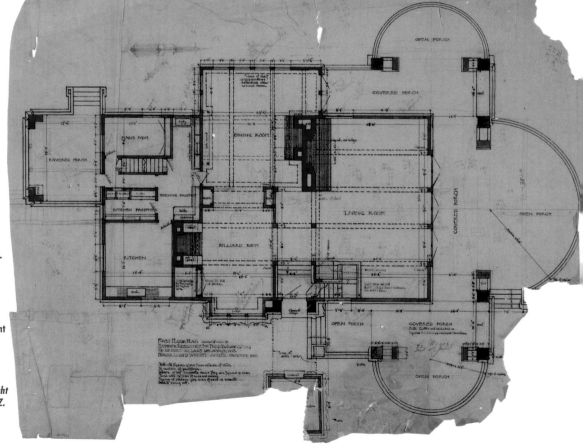

Wright proposed curved outer walls for the three porches at the main house. Faint pencil lines on his drawing show that he reconsidered the idea—perhaps because of the challenges of realizing those details—and straight walls were built instead. All three porches now have the curved walls Wright envisioned.
© 2019 Frank Lloyd Wright Foundation, Scottsdale, AZ. All rights reserved.

"Unfortunately the studies are lost with thousands of others of many other buildings: the fruit of similar struggles to coordinate and perfect them as organic entities—I wish I had kept them."[12] Thus, any possible missing Penwern drawings may have been among the ones "lost or discarded" when Wright closed the Oak Park Studio at his home after abandoning his family in 1909 and moving his studio to Taliesin in Spring Green, Wisconsin, two years later.[13]

Wright often explored a variety of ideas in the process of developing his conceptual design sketches. He is known to have reprised elements from previous designs in new projects. As such, perhaps the most significant drawing for Penwern is one made for Henry H. Wallis on September 15, 1900, just a few weeks before the first floor plan for Penwern's main house.[14] It could shed light on Wright's creative thoughts as he designed Penwern, although there is no way of knowing when he first conceived of his design. Paul Kruty, professor emeritus of architectural history at the University of Illinois, Urbana-Champaign, gives insight into the drafting of working drawings as "a very tedious process. . . . [Draftsmen] don't want to start that process until Wright has stopped designing. That is the very last thing that happens. When did the idea really occur to the architect?"[15]

Wallis's proposed new home was just a few lots west of where Jones would build Penwern. For reasons unknown, Wright's first design (known as "Henry Wallis Summer Cottage scheme 1 or Project 0006" in the Wright archives) was not satisfactory. The house as realized ("scheme 2," now known as the Wallis–GoodSmith House) lacks the arched porte-cochère from "scheme 1."

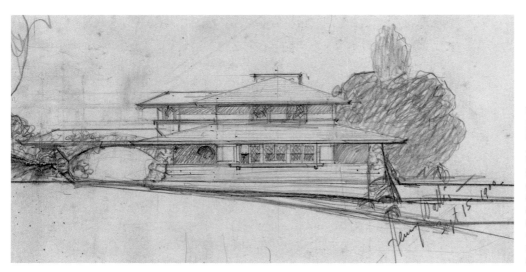

Wright designed a house for Henry H. Wallis just a few lots west of where Fred B. Jones would build Penwern. Wright's initial proposal for Wallis included an arched porte-cochère—a detail Wallis ultimately did not get, but that Jones did get at Penwern.

WALLIS SCHEME ONE LAKE DELAVAN WI FLW 1900
CONCEPT DRAWING W/ TOWER ©ROBERT HARTMANN 12/2017
©REVISED BY RH 1/2018

Architectural designer Robert Hartmann used Wright's faint pencil lines on the Wallis scheme 1 drawing as the basis for this interpretive concept rendering, showing a tower and a covered walkway above the porte-cochère. It is unknown if Wright was proposing these details for Henry H. Wallis, or if he was using a drawing for Wallis to try out these ideas for Fred B. Jones. © Robert Hartmann

Close examination of one of the drawings for Wallis 1 by architectural designer Robert Hartmann shows faint pencil lines suggesting a covered walkway above the proposed porte-cochère with a tower at the end of it, opposite the house.[16] While they were not built for Wallis, an arched porte-cochère, a covered walkway above it, and a tower are signature features of Penwern.

There are two possible explanations for the faint pencil sketches of the walkway and tower at Wallis 1. Did Wright propose these features for Wallis before building them for Jones?[17] Or did he simply use a sheet from one discarded plan on which to outline ideas for another?[18]

A TRANSITIONAL ARCHITECTURAL STATEMENT

Penwern's main house was designed in the period between three of Wright's earliest Prairie-style houses, the Bradley, Hickox, and Willits Houses. Although Penwern is not cast in the forms characteristic of Wright's mature architecture, it has important elements of what would become known as his Prairie style.

Henry-Russell Hitchcock, who, with Wright's assistance, assembled and published the first major inventory and analysis of Wright's work, wrote that Wright's architectural vocabulary was

still evolving at the turn of the century. Noting that by 1900 "in almost all respects [Wright's] maturity is complete,"[19] he hastened to add, "but the houses of 1900, and even a few works of the next year or two, still have transitional elements."[20]

Harvard University professor Neil Levine concurs: "Wright's work between 1894 and 1900 follows no single, straightforward course, as it fundamentally would in the following decade. It took him a certain amount of time to try out different approaches and, especially, to see how the [Louis] Sullivan model could be expanded and reworked to suit his own purposes. The work of these years shows an openness to new and progressive influences, despite the strong will to create something personal and integral."[21]

The transition in question was, of course, to Wright's Prairie-style homes. Wright reflected passionately on their design attributes in *An Autobiography*, first published in 1932. "What was the matter with the kind of house I found on the prairie?. . . Just for a beginning, let's say that house lied about everything. It had no sense of Unity at all nor any such sense for space as should belong to a free man among a free people in a free country. . . . It was a box, too, cut full of holes to let in light and air, an especially ugly one to get in and out of. . . . My first feeling therefore had been a yearning for simplicity. A new sense of simplicity as 'organic.'"[22]

JAPANESE INFLUENCES ON WRIGHT

Scholars have taken note of the apparent influence of Japanese architecture on Wright's work. Although Wright did not travel to Japan until 1905, accompanied by his wife and his clients Ward and Cecilia Willits, there is widespread belief that Wright visited, and was moved by, the Ho-o-den, the Japanese pavilion at the World's Columbian Exposition in Chicago in 1893.[23] The house was a model of domestic simplicity, in stark contrast to the Victorian norm of many American homes. Of their interiors, wrote Wright, "Dwellings of that period were cut up. . . . The interiors consisted of boxes beside boxes or inside boxes, called rooms. All boxes were inside a complicated outside boxing. Each domestic function was properly box to box."[24] Wright "unboxed" Penwern when he designed the first floor of the main house.

One of the architect's biographers, Grant Carpenter Manson, wrote, "As if to underwrite this thought there was a brief period in the months just after the opening of the twentieth century when Wright designed some houses with undisguised Japanese details. They belong neither to the transitional period nor to that which followed; they are sports, in a class by themselves, but very revealing." Of the four buildings on the Penwern estate, Manson singled out the boathouse for mention because of how it evokes Japanese style. He captioned a photo of the boathouse "the spirit of Yedo [an ancient name for Tokyo] on the shores of Lake Delavan."[25]

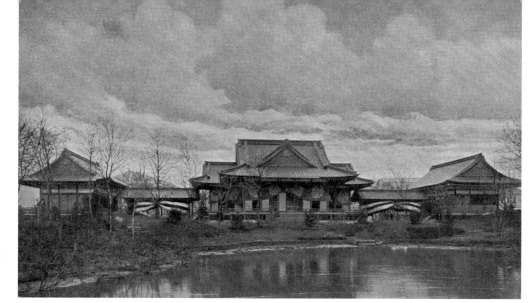

The grace and elegance of Japanese architecture, as seen in the Ho-o-den pavilion at the World's Columbian Exposition in Chicago in 1893, is widely thought to have inspired Frank Lloyd Wright. *WHi Image ID 139104*

Says Paul Kruty, "The boathouse is an experiment in working with Oriental, particularly Japanese forms, which Wright was to integrate into his thinking soon after—but here it just jumps out at you."[26]

Architect, Wright scholar, and past president of the Frank Lloyd Wright Building Conservancy Jon Lipman writes that the boathouse "suggested a Shinto shrine atop a battered fieldstone base."[27]

Japanese design influence can be seen in the raised roof ridge lines Wright incorporated on three of the four structures at Penwern, including the boathouse.

Holzhueter is entranced by the boathouse and the gate lodge. "The [boathouse] building is both 'of the hillside' and 'of the lake.' It offers shelter and expansive views. From the estate you'd never guess it was a boathouse; it is merely a pavilion. From the water, its purpose is extremely obvious. . . . The large entrance for boats makes it appear that you are entering a cave on the lakeshore—a cave with leaded glass windows. It is just a perfect space, ideally suited for its purposes, and a summary of Wright's intention for all his work at Penwern."[28]

And, about the gate lodge, Holzhueter notes that "small dwellings with so much architectural richness are always charming. It is a storybook house before Hollywood invented them. It is the ultimate retreat: robust foundations, elaborate dormers, Japonesque roofline, a wrought-iron gate, lanterns, lattice-work water tower, recessed entry, tidy-to-the-max floor plan, nifty closets and shelving. Wright didn't do 'charming' very often, but

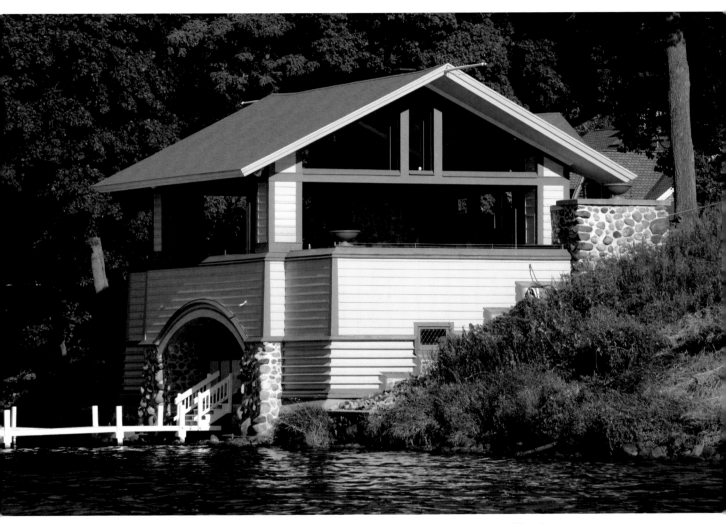

The boathouse's broad eaves echo the lines of the Ho-o-den. Wright adapted a Japanese domestic design for what could have been dismissed as simply a utilitarian building that need not be elegant.

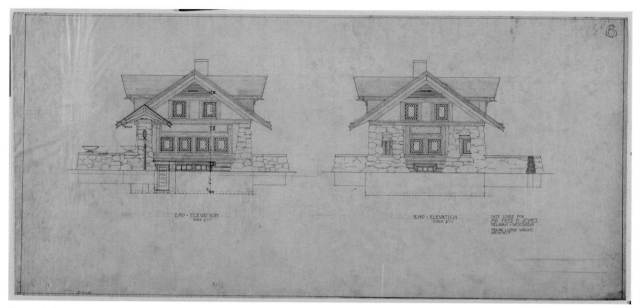

The gate lodge is an enchanting building even when considered out of context with the rest of the estate.

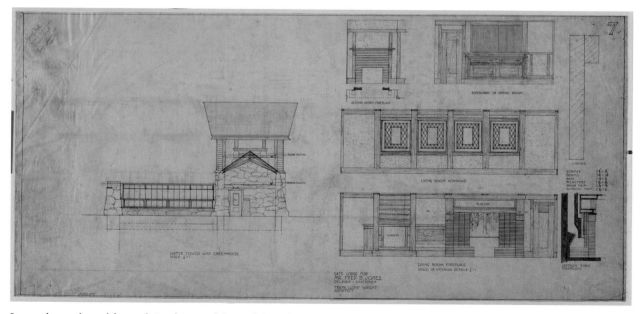

Because the greenhouse, left, was designed as part of the gate lodge, it has not been considered a separate Wright building.

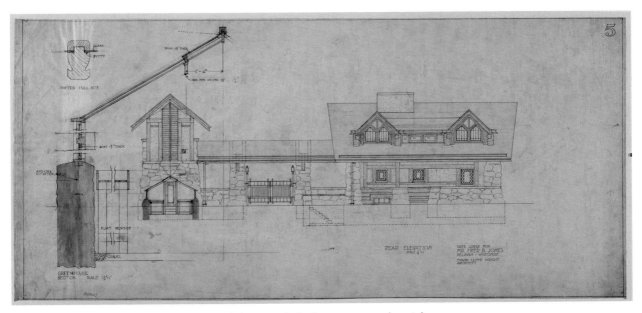

The gate lodge water tower, at left, punctuates the gate lodge just as the Pavilion tower accents the main house.

when he did, he did it exceptionally well. Jacobs I [Wright's 1936 Herbert and Katherine Jacobs House in Madison, Wisconsin] has about the same square footage. When you look at it, you think 'beautiful.' When you look at the gate lodge, you think 'charming.' It's in the way Wright handles the details."

DESIGNING PENWERN

Curved lines are a unifying design element of the house and boathouse at Penwern. As one approaches the house, the arched porte-cochère, with the lake visible beyond, is the focal point. Another segmental arch, 28 feet long, spans the front porch. It defines the transition between sheltered and open space, framing the view of the lake from the living room.[29] The front porch and the two adjacent side porches were designed with curved outer walls, complementing the porte-cochère and the arch above the front porch especially when viewed from the lake side.[30] Inside the house, the Roman brick fireplaces in the billiard and living rooms are arched.

The arch above the doors on the front of the boathouse echoes the house behind it, atop the sloping lake bank. The symmetry among the boathouse, the porte-cochère, and the front porch arch at the house is striking when viewed from the lake.

A final curving accent is a subtle feature at the gate lodge. It is best understood viewing the drawing of the floor plan of the gate lodge. The gate lodge itself has sharply angular features,

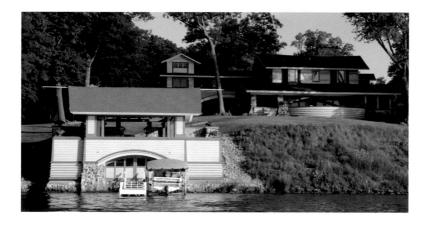

Penwern was commissioned during Frank Lloyd Wright's transition to his Prairie-style designs. The curved accents contrast with the strong horizontal aspects of the Prairie style.

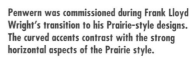

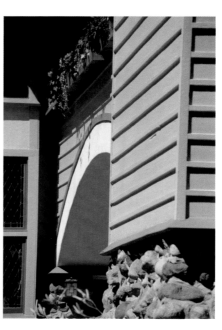

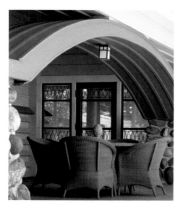

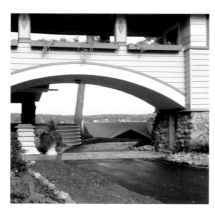

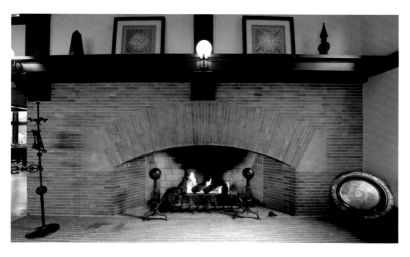

but a semicircular boulder wall enclosed the east end of the gate lodge grounds, including the water tower and the original greenhouse. About half of the wall is missing, apparently having been taken down sometime after the property was subdivided in 1989.[31] Its foundation was uncovered in October 2017, along with the floor and irrigation pipes of the greenhouse. Current stewards John and Sue Major plan to reconstruct both the wall and the greenhouse.[32]

Adjoining the main house's porte-cochère is the two-and-a-half-story tower, an exclamation point to the house. It is opposite the front door, connected to the house by the covered open walkway above the porte-cochère. It would be mirrored two years later by the water tower at the east end of the gate lodge. The walkway connecting the tower to the house leads to a balcony inside, overlooking the billiard and living rooms.

The tower has just one room, where Jones and his guests played cards; it was central to the men's entertainment. Jones added a useful fixture from the Adlake catalogue: a metal water faucet shielded in a semicircular metal housing. A popular (undocumented) anecdote explains that the men used it to mix drinks like whisky and water. The device looks like a simple fixture, but

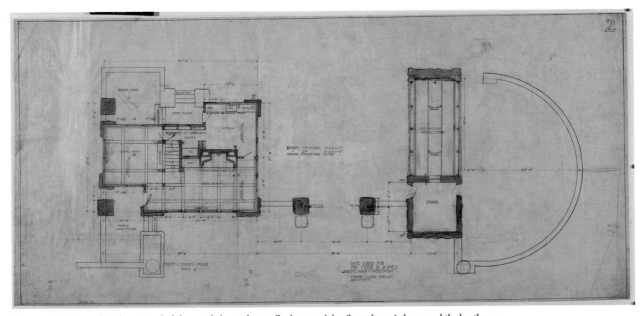

The curved boulder wall at the east end of the gate lodge, right, recalls the curved details at the main house and the boathouse.

the description in the catalogue of "Trimmings" for "railway cars and steamships" is not obvious: they are a "No. 31 Lever Coupling Bibb" and a "No. 6 Alcove." An identical fixture was in the billiard room. A water "tank room" above the card room is accessed by ladder from the card room. The door at the base of the tower leads to a small ground-floor storage space.

The prominent curving lines at Penwern contrast with the rooflines with their wide flying gables and raked eaves, similar to those on the Bradley and Hickox Houses. Some eaves shelter dormer windows. Two of the three windows in each of the bedrooms upstairs in the gate lodge are dormer windows, similar to the second-floor windows on the front of Wright's 1900 Stephen A. Foster Cottage in the West Pullman neighborhood on Chicago's Far South Side.

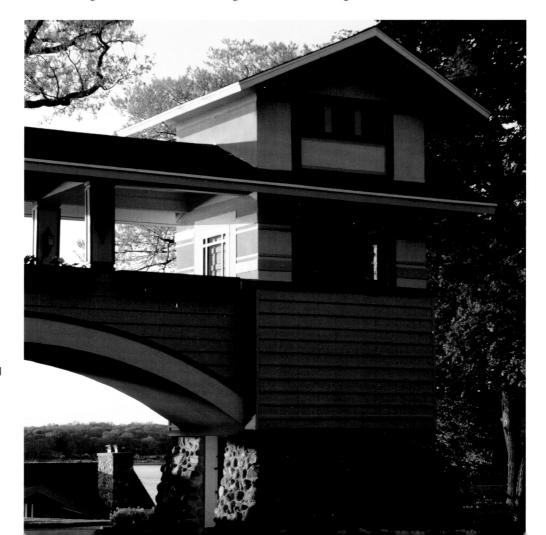

Frank Lloyd Wright called the tower at the main house the "Pavilion." The space truly was the domain of men; a built-in urinal drained to the ground below.

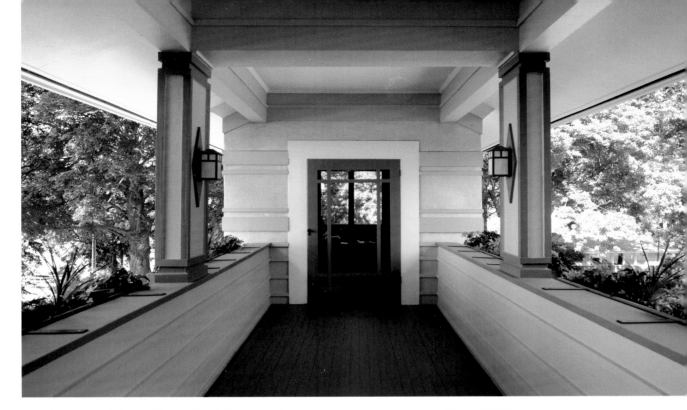

The ends of the gable roofs of the main house, boathouse, and stable have flared or raised ridge lines, seemingly another acknowledgment of the grace of Japanese styling. The ridge beams at Penwern rise approximately one inch every foot beyond the exterior wall.[33] Wright employed the same design detail earlier in 1900 on both the Foster and Hickox Houses. Robert Hartmann notes that the stable is Wright's sole post-1900 design with raised ridges.[34]

The gate lodge is exempt from this roof treatment. Hartmann suggests not considering the gate lodge an anomaly even though it is the only structure at Penwern without a raised ridge roofline. He speculates that though it was constructed after the gate lodge, the stable may have been designed before Wright abandoned raised or flared roof ridges in favor of straight rooflines.[35] He adds, "The flared roof on the stable, even though it comes in 1904, is necessary because Wright recognizes that the stable engages the main house and boat house. For this reason he employs a unifying roof line to all three structures."[36]

The tower card room is at the end of the covered walkway above the porte-cochère.

Hardware fixtures for rail cars and steamships made by Adlake, Fred B. Jones's company, were useful for getting water for mixed drinks in the Pavilion and in the billiard room.

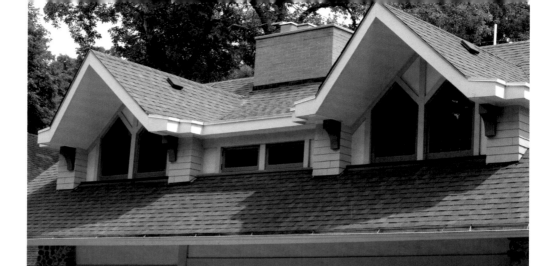

The broad eaves on the north side of the gate lodge helped shelter the house from the summer sun in the days before air conditioning.

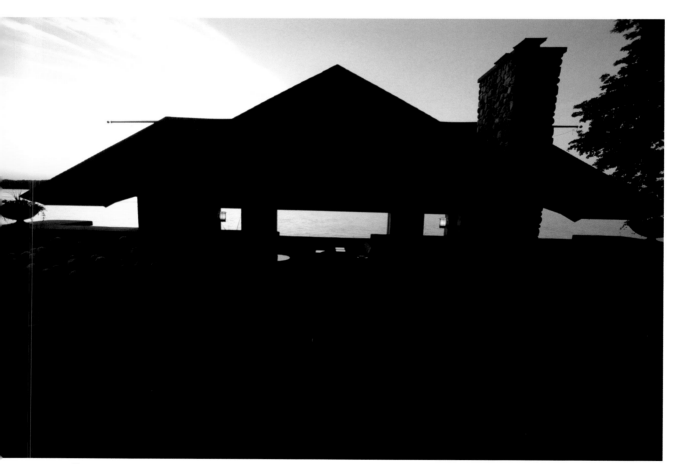

Sunset silhouettes the flared ridge lines of the boathouse roof.

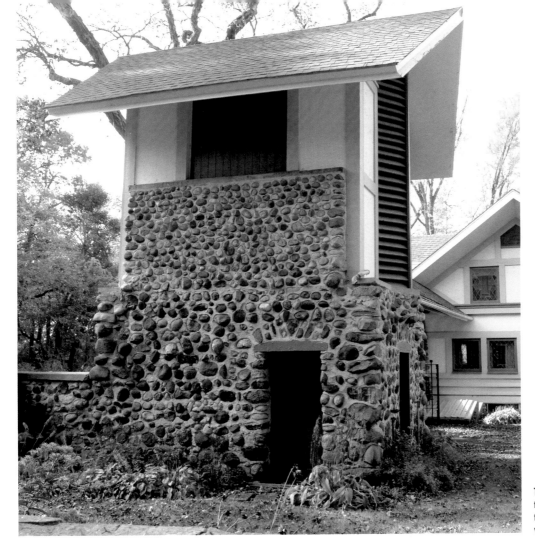

The gate lodge water tower is firmly tied to the earth by a robust wall of boulders.

The year-round caretaker lived at the gate lodge, so it is reasonable to suggest that it was built before the stable because there was only one servant's bedroom in the main house until the 1909–1910 additions were constructed. Jones was fond of growing roses in the greenhouse Wright placed between the gate lodge water tower and surrounding stone wall, and he instructed his caretaker to pay particular attention to the roses in the greenhouse during winter.[37] Jones had a second, larger greenhouse built at an unknown date on the west side of the gate lodge. A large wood cistern still exists on the upper level of the water tower. Both greenhouses are gone.

The stable was built mostly according to Wright's plan. An exception is the front of the stable, where the boards and battens are not as high as Wright specified in his drawings. This suggests that he exercised little or no supervision over its construction. An undated vintage photo of the stable shows two windows, side by side, on either side of the front elevation of the structure, just

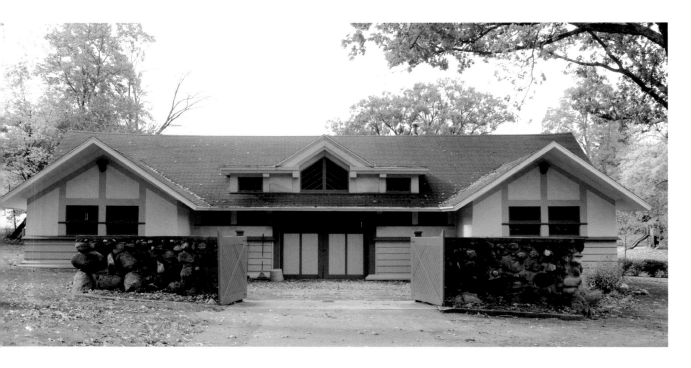

The changing colors of fall frame the elegant yet functional stable.

as on the plans. An additional pair of windows was added below each pair of front windows at an unknown date.[38] A door on the north side of the stable was for the ice house. Wright's floor plan for the structure refers to an "old barn," but today there is no evidence of such a structure. The floor plan indicates a stove near the "oat chute" and a harness room near the entrance, well away from the paddocks for the horses. The paddocks, at the rear of the structure, were surrounded by a "wire fence" and an "iron gate."

The boathouse is an inviting, airy structure. The top floor, described as a "Covered Pavilion" by the architect, is open on all four sides. Stairs lead down to the lake level, which was originally designed with a boat slip. The original boathouse was destroyed by arson in 1978; when it was rebuilt in 2005 the boat slip was replaced by a concrete floor to comply with new regulations about boat storage from the state Department of Natural Resources.[39] Today it is used to store small watercraft like kayaks. The pavilion has always been an inviting venue for entertaining guests during the summer, particularly as the sun sets across the opposite shore of the lake. Delavan historian Allen Buzzell suggests that for some people, the south shore of the lake was a more desirable location to build than the north shore because people were more likely to enjoy seeing sunset than sunrise.[40] Originally there was only a small firebox on the lower level suitable for warming guests who had been ice skating or ice boating on the lake, or to warm workers chopping ice. The rebuilt boathouse has a fireplace on the pavilion level.

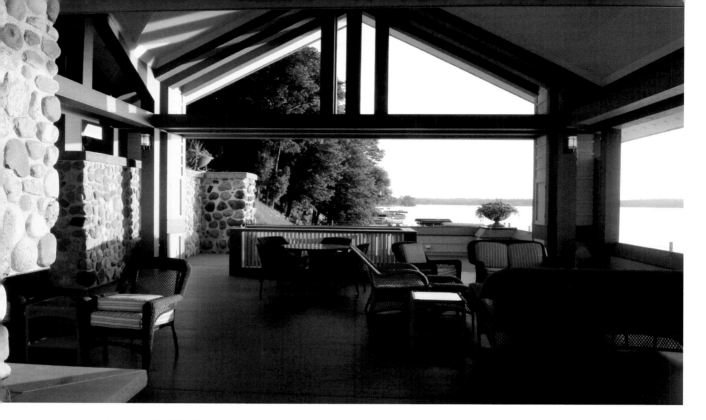

In the boathouse pavilion, chairs are clustered to encourage visitors to take in the sunset view; others, at left, face the fireplace.

The boathouse's boulder piers are framed by the diamond-shaped window panes in the sliding doors.

BUILDING MATERIALS

Frank Lloyd Wright frequently used natural local materials. This boulder bridge takes visitors across a culvert between the stable and the main house.

Four of Wright's five Delavan Lake houses had board-and-batten construction, at least on the first floor (the fifth and last one, A. P. Johnson, was tongue and groove). The protruding battens on the base of the Jones house are angled, perhaps to shed water from the foundation, while the wall above has flat boards with simple battens.[41] Wright used plaster, with wood trim, for the upper outer walls of all four buildings.

Boulders—"Bowlders" on one of the building plans—are a natural building material found in all four structures at Penwern. Portions of the house and the tower rest on a fieldstone base. The approach from the gate lodge to the house is over a low boulder bridge placed over what was likely simply a gully for rain runoff. A concrete cap rises in the middle of the bridge in a triangle, contrasting with an arch over the gully below.

There are also fieldstone columns on the front porch and at the gate lodge. The fieldstones tie the structures to the earth, both symbolically and structurally. The use of fieldstones is similar to Wright's Chauncey Williams House in River Forest, Illinois (1895) and Wallis 1.

Sturdy boulders form the wall that once surrounded much of the original greenhouse at the gate lodge.

Boards and battens were carefully cut or scribed to fit around the boulders in piers at Penwern.

EXPERIENCING PENWERN

The visitor's experience at Penwern after 1903 began at the road, at the newly constructed gate lodge, where Wright prominently mounted a plaque with the name *Penwern* in a stone pier at the entrance to the estate (see page xxxi). The plaque was not a last-minute addition or a whim; it is shown on one of Wright's drawings.

One emerges from under this sheltered entrance to encounter the house in the distance, down a sloping landscape leading to the lake. The stable is to the left, between the gate lodge and the main house. The boathouse is slightly east of the main house, below a steeper slope.

A long stone wall along South Shore Drive next to the gate lodge marks the south edge of the property. It is not known if it was erected when the house was built or when the gate lodge was constructed two years later. If the wall was built concurrently with the gate lodge, what was the earlier entrance to Penwern like?

Also unknown are what the grounds looked like when shovels began to turn the earth to build Penwern and who designed the landscaping. A postcard view of Penwern mailed in 1911 shows a robust grouping of mature trees between the main house and the boathouse. Associate Professor Christopher Vernon, a Walter Burley Griffin scholar at the University of Western Australia, believes it is reasonable to suspect that famed Chicago architect Griffin had a hand

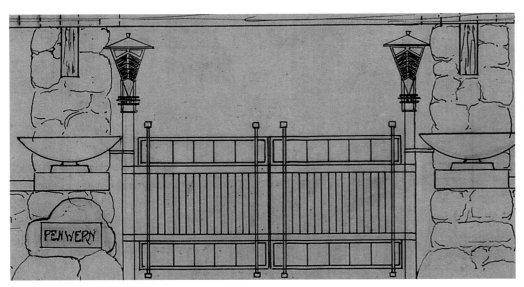

Wright generally eschewed signage on his works, but he prominently identified Penwern in the design for the gate lodge.

in developing the site plan or landscape architecture: "Circumstances suggest Griffin's involvement. It was a fairly complex site relative to, say, a lot in Oak Park, one that may well have required landscape architectural or 'site planning' abilities—not Wright's strong point."[42] Griffin is credited with the landscape plan for the Willits House. However, a 1903 newspaper account credits an otherwise unknown landscaper: "F. B. Jones is having a well known landscape gardener, Mr. Doerrica, lay out his entire grounds in a beautiful park."[43]

It is reasonable to ponder how to define the "front" of the main house, usually thought of as the facade first encountered by visitors. At Penwern that would be the south side of the house. However, the expansive porch on the north side, facing the lake, is commonly referred to as the "front porch." The entrance door and entry hall are on the east side of the house, under the porte-cochère, identical to the placement of the entry to the Bradley House.

The term "path of discovery" is sometimes used to describe Wright's technique of leading visitors from a low and unexpected entry space into joyful living space. The practice is also called "compression and release" and is seen at other Wright sites.

Viewed from below, the arch of the porte-cochère is like an arrow pointing down to the front door. The door is extraordinarily large, 58 inches wide, also similar to the Bradley House, whose front door, on the side of the house, is 54 inches wide.[44] The ceiling just inside Penwern's front door is 8 feet 6 inches high. Visitors ascend four steps to the entry hall to find that the ceiling is 2 feet lower. This allowed Wright to tease people with a sense of confinement in the entry hall, a feeling that disappears quickly in a burst of open space.

If the gate lodge is a visual teaser for visitors, the main house is the splendor at the end of the driveway.

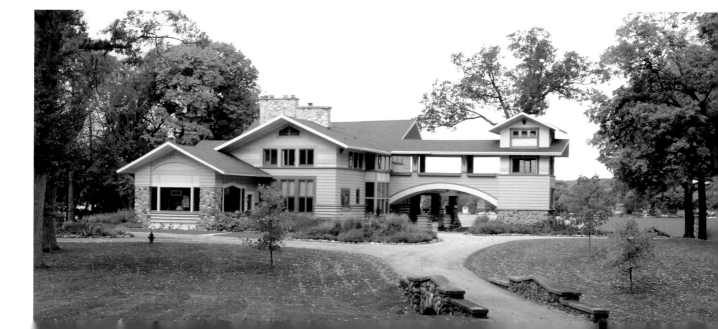

The dining room fireplace is directly behind the living room fireplace, centered to the dining room table and the buffet on the opposite wall. The billiard room fireplace is centered as well.

The living room stairs to the second floor and balcony are not the typical long staircase or one with only one landing. Instead, there are three intermediate landings, two of which seem particularly purposeful. The lower and larger of the two is just 43 inches above the living room floor; the second is a foot higher. The landings provide an opportunity to look directly into the living room and interact with others, or to reflect and gaze out toward the lake. A 9-inch-wide shelf tops the wood screen banisters. It reinforces what seems to be Wright's invitation to linger on the landings as a place to rest one's arms while leaning over to take in the view or talk to people.

The wood screen sides of the stairs have square spindles turned at 45-degree angles and appear triangular when viewed head-on. These openings are airy, unlike the conventional plaster or wood that could have encapsulated the stairs. Wright, who used such screens in many homes, also placed one as an outer boundary of the billiard room and another between the gate lodge dining room and stairs.

Not even Jones had a private bathroom when the house was constructed. All five bedrooms on the second floor shared a single large bathroom down the hall from the master bedroom. The bedrooms have all been remodeled, and each now has a private bath.

Situated above the living room, the master bedroom— originally Fred B. Jones's bedroom— was the only original bedroom in the main house designed with a fireplace.

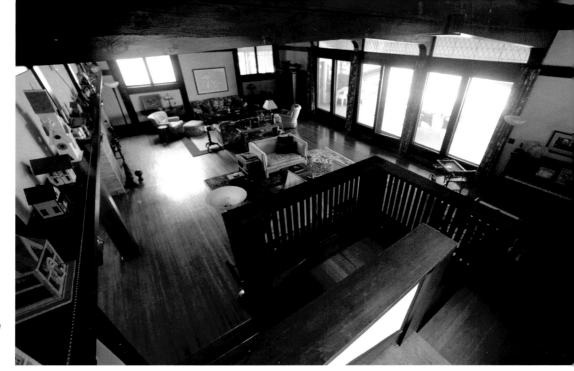

A few steps down from the balcony, a landing provides a commanding view of the living room.

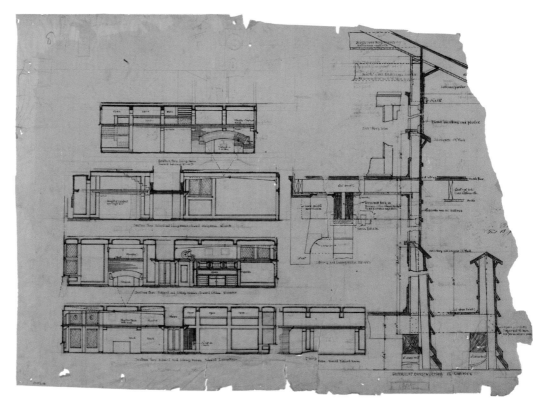

Wright is not known to have designed any freestanding furniture for Penwern, but he gave careful attention to built-in furnishings in the gate lodge and in the main house.

FURNISHINGS AND WINDOWS

Wright was known for his attention to detail beyond the design of a building. His furniture and windows were often as significant as the structure that enclosed them. Evidently Wright did not have a hand in any of Jones's furniture in the main house except for two pieces shown on his plans. They are still in the house. One is the built-in buffet in the dining room, the other, a liquor cabinet in the billiard room. The latter is on casters—Wright's plans note "Case To roll in place"—and hid the door to a safe room. The plans for the safe room called for zinc lining the floor and two feet high on the walls.[51] Wright also designed a built-in buffet in the gate lodge.

Although Wright did not make art glass designs for the windows at Penwern as he had for Bradley and Hickox (though he did design lovely windows for the Penwern dining room buffet and the liquor cabinet in the billiard room), he would not have been satisfied simply giving Jones unadorned panes of glass. Observes Blake, "Wright realized that large sheets of glass looked blank, black and dead from the outside, and tended to reflect only a single image of nature; a leaded window or a broken-up expanse of glass tended to look like a glittering mosaic of many

Four leaded-glass windows in the billiard room liquor cabinet feature a delightful interplay of contrasting geometric shapes.

Wright used windows at Penwern to make optimal use of natural light.

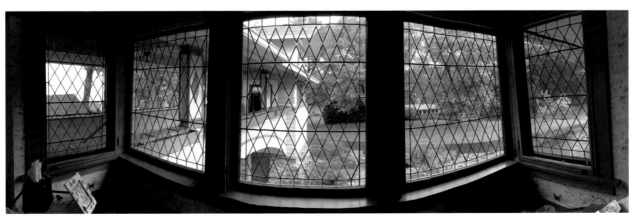

facets and color when seen from the outside. . . . As a result, each little pane of glass reflects a different part of the sky or the sun or the trees, and instead of appearing dull and dead, a fragmented glass wall becomes a rich mosaic, constantly changing in the light."[52]

The leaded glass windows in the main house, boathouse, and gate lodge feature a diamond pattern. Depending on the angle from which they are viewed and the time of day, they sometimes reflect the natural surroundings. Some of the groups of windows in the main house are early examples of Wright's Prairie-style ribbons or curtains of light. Julie Sloan, who curated "Light Screens: The Leaded Glass of Frank Lloyd Wright," a traveling national museum exhibit in 2001–2003, says the leaded diamond pattern in most of Penwern's windows was not unusual. "It's definitely a commercial pattern. Every diamond window has to be designed to fit that opening. The size of the diamond is designed to fit that opening. He didn't necessarily design it. Any stained glass company could have done it."[53] Rolf Achilles, who has also studied Wright's windows extensively, identifies the diamond design as being laid over rolled, rippled glass commercially produced in Kokomo, Indiana.[54]

The windows that open are casement windows, a style Wright preferred to double-hung (sash) or "guillotine" windows.[55] Bands of casement windows minimized the physical barrier between the interior living space and the outdoors, unlike the seemingly randomly placed sash windows in conventional homes. Wright likened sash windows to holes punched in a wall with little thought to their placement.[56] Casement windows also afforded the homeowner an effective means of ventilation before home air conditioning.

Wright had a keen sense of where light would fall in different rooms throughout the day. Not only did his windows bring natural light into the house, but he knew that sunlight would help warm a room in colder weather, and shade would cool it in summer. One grouping of three trapezoid-shaped windows at the head of the back stairs illuminates a dark corridor near the bedrooms.

The windows on the front of the boathouse are similar to those in the main house. Many of the gate lodge windows have a clear glass rectangle in the middle of the diamond pattern. The caming, or dividers between panes, lends an element of design to the larger windows on the front of the stable. The stable windows are plain. The ones over the entrance to the stable are two pairs of four parallelograms and two triangles, forming a chevron.

THE GATE LODGE

The gate lodge, like the main house, is two stories, but it is more compact and has a significantly lower profile than the main house because of the dormer windows on the front and rear sides of the gable roof. The gate lodge is a lovely building in and of itself, but it is rarely considered separately from the rest of Penwern. Jack Holzhueter is of the opinion that "the beauty in that estate comes in the ancillary buildings . . . the gatehouse and the attendant building. . . . The plan of the gatehouse is one of the most charming Wright ever created, when he was creating charming houses. It's exactly the same date as the Lamp House in Madison, which is very charming. It has wonderful gables and dormers, which harken back to an earlier part of his career."[57]

The first floor is compact, but open. It has just three rooms: the living room is to the right of the front door and the dining room to the left; a small kitchen is behind the living room hearth. The dining room is open both to the entryway and kitchen. The stairs are opposite the front door, between the living and dining rooms. A quote from Robert Frost—"I have taken the road less traveled by and that has made all the difference"—appears above the living room fireplace. Wright designed the lodge with four bedrooms, two with fireplaces, and one bathroom upstairs.

The angles of the gate lodge design are in contrast with the curved accents of the main house.

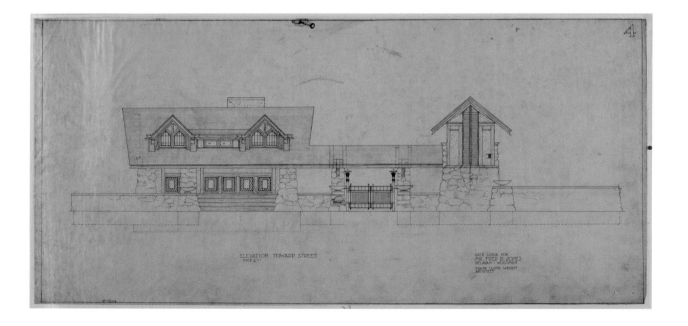

ELEVATION TOWARD STREET

GATE LODGE FOR
MR. FRED B. JONES
DELAVAN · WISCONSIN
FRANK LLOYD WRIGHT
ARCHITECT

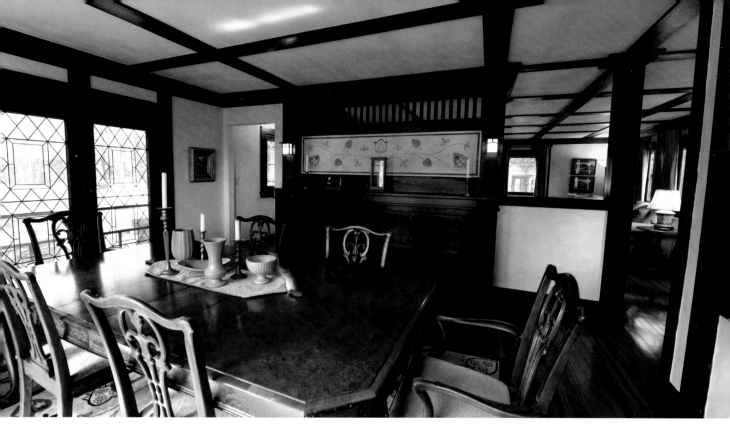

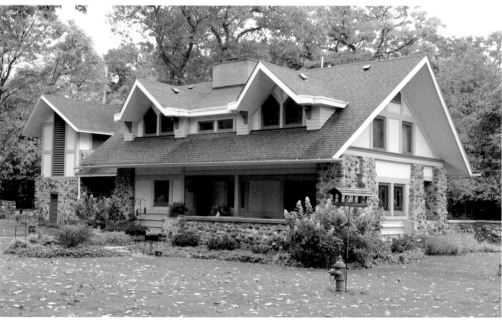

Wright designed a hutch for the center of the compact gate lodge dining room. The living room is partially visible at right, past the bottom landing of the stairs to the bedrooms.

Wright historian Jack Holzhueter calls the gate lodge one of the architect's most charming designs.

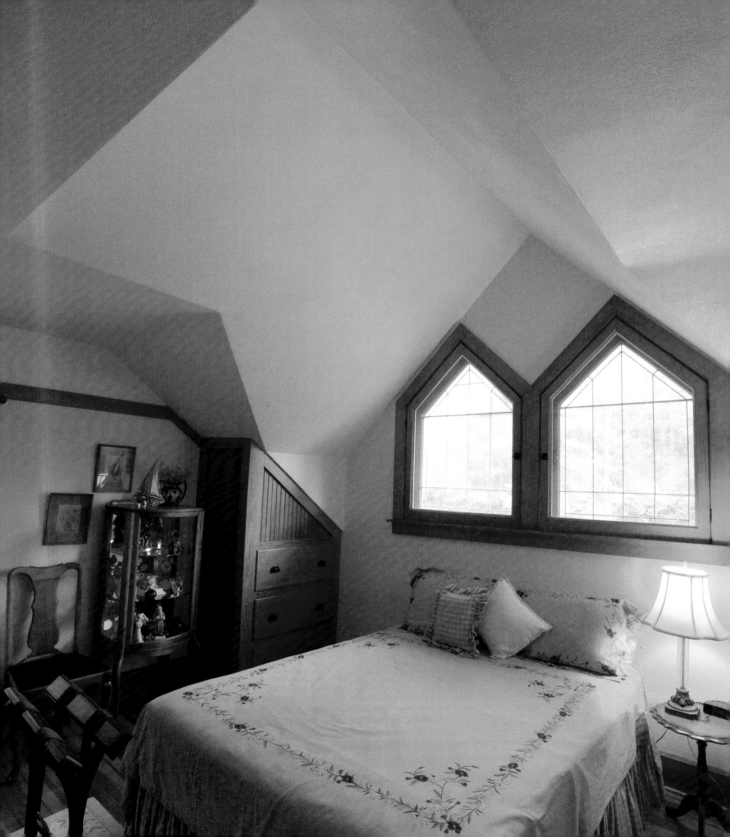

WRIGHT'S DESIGN IS ALTERED

Jones's needs evidently changed within a decade, spurring him to commission additions built in 1909 and 1910.[58] Constructed by Tunis Moore, the contractor who built Penwern, they were indifferent to Wright's design. Not only did they destroy the integrity of the original design, but the one on the west side of the house, which contained one large bedroom and full bath, astonishingly covered several of the six large dining room windows.[59]

The south addition, visible as visitors approached the house, replaced the "Covered Porch" adjacent to the pantries and the "Man's Room." Two and a half stories high, it had five bedrooms. There were servants' quarters downstairs, including a galley kitchen, sitting room, and bath. The second-floor bedroom had a screened-in porch, a fireplace similar to the one in the gate lodge, and an inglenook. A large bathroom with a tub and closet was up another half-flight of stairs. It is possible Jones began planning for the additions as early as March 1905, according to a brief news item in a local paper that said he was "out from Chicago Friday, planning several improvements that he intends to make about his residence.[60]

His reasons for the additions are not known. It is likely Jones did not realize how large a staff he would need to take care of the property and attend to his numerous summer guests: an inventory of the estate after his death in 1933 listed three servants' rooms and a chauffeur's

(opposite)
The window frames in the gate lodge bedrooms echo the gables above.

This photo, taken in 1972 to support the National Register of Historic Places nomination for Penwern, shows Jones's addition to the west side of the main house. *Courtesy of the Wisconsin State Historic Preservation Office*

room, meaning four of the six bedrooms were for staff. They were furnished simply compared to the other two bedrooms.[61] Indeed, a notice in the local newspaper before the start of the 1905 summer season announced that "the old barn [no remnants of which are apparent] is to be converted into a laundry and servants' quarters."[62] It is also possible that the large bedroom with porch, fireplace, and large bathroom was for Mrs. Mortimer. It has been suggested that the additions were for his mother or grandmother, but both women died before the initial construction of the main house.

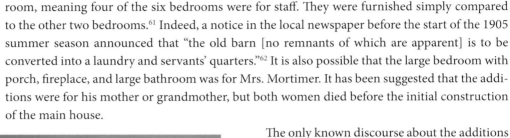

The kitchen in the main house has been redesigned for contemporary use and efficiency.

The only known discourse about the additions is found in a much later undated letter recounting that Penwern, "Wright's most ambitious endeavor in the area, was built for a bachelor by the name of Jones, but was changed about somewhat to suit Mr. Jones's aging problems."[63] In light of this last observation, it has been suggested that even though Jones was only about fifty-one when the additions were built, he may have already found it arduous or bothersome to climb stairs. Yet, the elaborate bedroom with cavernous bathroom, which would presumably have been his, was upstairs in the addition.

Sue and John Major removed the additions after they bought Penwern in 1994. After removing the south addition, they built an enclosed children's playroom on a slightly larger footprint than the original covered porch. Other than its size and being fully enclosed rather than open on the sides, it is similar to the demolished porch. It is now a family room. The original kitchen, kitchen pantry, and serving pantry have all been remodeled into a modern kitchen. The "Man's Room" adjacent to the back stairs, presumably a servant's bedroom, is now a breakfast nook.

Early photos of Penwern show straight porch walls. Did the curved porches fail and were they

replaced with straight walls, or, more likely, were they deemed too difficult to construct, as Robert Hartmann suggests?[64] Hartmann greatly enlarged the construction drawings in 2017 and found faint pencil lines indicating that straight walls should be built instead of curved ones, anchored to the boulder piers by short board and battens at right angles to the walls. Indeed, Bill Orkild, the Majors' construction manager, has found evidence of porch walls having originally been attached to the outside edges of the piers. This is more than an esoteric inquiry; it is critical to understanding Wright's vision. All three porches have been reconstructed with curved walls.

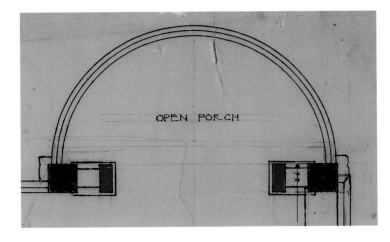

OPEN PORCH

There were several alterations made to the gate lodge by the Robbins family, members of which owned it from 1939 to 2000. The greenhouse shown on Wright's plans had deteriorated by the mid-1970s. The Robbins family tore it down and erected a carport over its foundation.[65] The Majors removed the carport, the second greenhouse that Jones had built at the north end of the gate lodge, which had also deteriorated, and a mid-1970s enclosure of the small open porch by the back door.

The paddocks or stalls for horses at the rear of the stable were torn down after the property was subdivided in 1989. The gate lodge water tower still stands, but a 12,000-gallon water tank on a 50-foot stand built between the gate lodge and the stable in 1917 for fire protection is gone. The tank, too, was lost, along with a trellis possibly designed by Wright, when the estate was subdivided.

The Penwern estate has garnered several architectural honors, including National Register status, but Penwern is greater than the words on a citation. While Wright designed four other summer "cottages" on Delavan Lake between 1900 and 1905, none of them received as much attention in early weekly newspaper accounts or in modern Wright circles as Penwern. There are, to be certain, countless unanswered questions about Jones and about his estate. Largely restored to Jones's and Wright's original intent, Penwern continues to enthrall visitors.

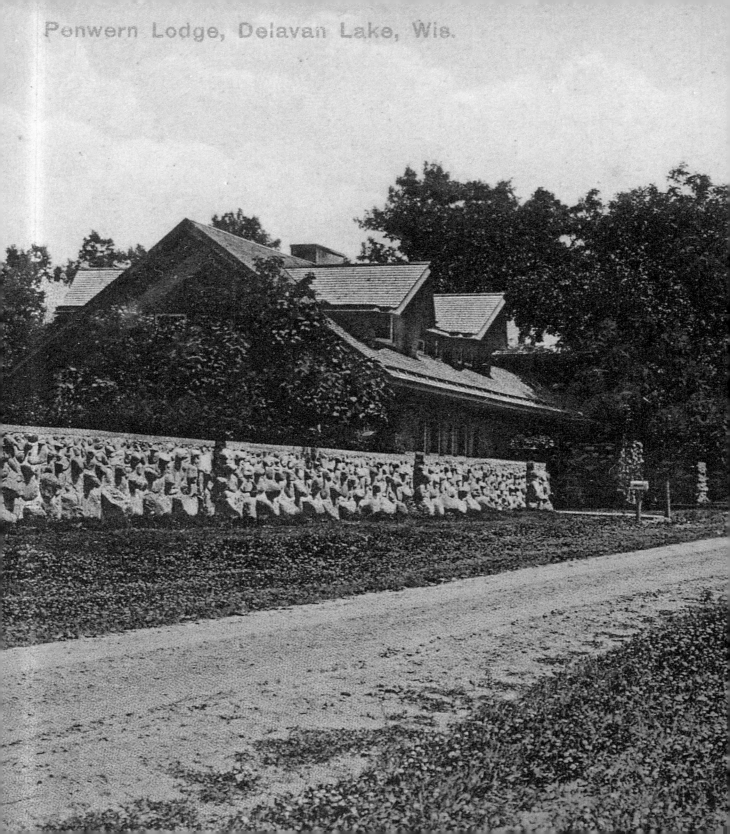

Penwern Lodge, Delavan Lake, Wis.

Stewards
of Penwern

3

Penwern could have deteriorated or even withered away after Fred B. Jones died in 1933. After all, he had made no provision for the disposition of the estate in his will. Penwern's fate was arguably uncertain each time it was sold. But fortunately, each time it was taken on by caring new stewards. Each new steward has carried on Jones's tradition of sharing the lake home with friends.

ROBBINS FAMILY MEMBERS
Burr and Peg Robbins (1939–1983); Ross Robbins (1983–1989); and Terry Robbins Canty (Gate Lodge, 1976–2000)

After the death of Fred B. Jones in 1933, Penwern could not be sold until the cousins' lawsuit against the estate was settled. That left the home without a steward until Burr and Peg (Margaret) Robbins bought the property in 1939.

Maintenance costs accumulated in the interim, to prevent the estate from deteriorating while legal pleadings flew back and forth in Cook County Probate Court. The final accounting for the estate included $10,630.96 ($188,000 today) for expenses such as property insurance, coal, flower seed, grass seed, tree trimming, $5 to Mrs.

The gate lodge has welcomed guests to Penwern since its completion 1903. There is no record of what the entry to the magnificent estate looked like between June 1901, when the main house was finished, and 1903.
Courtesy of John Hime

Clarence Carlson for cleaning the main house on April 18, 1934, and $5.36 for lawn mower parts. Administrative expenses of $2,110.10 ($37,200) included $46.44 for advertising the sale of "Penwern Lodge" in Chicago newspapers.

Although Jones's will left the contents of both his apartment and Penwern to Dora Mortimer, for unknown reasons some of the items were sold at auction. Perhaps they were things she did not want for her apartment in the Parkway. The contents of the house at Penwern, described as "Fine Furnishings," were advertised for auction in Chicago in July 1937. Listed for sale in the *Sunday Chicago Tribune* were "Bedroom, Library, Living Room, Dining Room, Breakfast Rooms, Porch Furniture, Pictures, Lamps, Draperies, Rugs. China, Glassware, Knabe Piano, Billiard and Pool Tables. Desks, Chairs, Chinese Curios, Lanterns, 500 Items. Bed and Table Linen, Blankets, Trunks, Electric Fans, Electric Bath Cabinet, Massage Table, Antique Carriage, Sleigh, Outboard Motor, Large Speed Boat, Silverware, Electric Refrigerator, Gas Range. Hundreds of Items of All Kinds."[1]

The estate was discharged from probate on June 30, 1938. Burr and Peg Robbins bought Penwern from the Continental Illinois National Bank and Trust Company the following August for $21,000 ($371,000). Their son, Ross, says that was "a real reasonable price. It was a huge undertaking if you bought it. I think it just scared people."[2]

The Robbins name was not unfamiliar in the area. Delavan has a rich circus history, and Burr's grandfather, also named Burr, owned circuses that wintered in nearby Janesville from about 1871 to 1888.[3] The younger Burr had several working farms near Delavan. They were named Robbinswood Farms, so he and Peg renamed the Penwern estate "Robbinswood" and the house "Robbinswood Lodge." They already had a summer lake home ten lots to the east, which they tore down after purchasing Penwern.

The estate became the Robbinses' weekend and summer home, just as it had been for Fred B. Jones. Like Jones, they kept their full-time residence in Chicago, where Burr ran the General Outdoor Advertising Company, an industry leader. They raised two children, Ross and his older sister, Terry. Ross first came to Delavan as an infant and was baptized at St. Andrew's Catholic Church as a two-week-old. "This is more my home than Chicago," he recalls. He was six when his parents bought Penwern, and he remembers that he and Terry sometimes got into mischief. "The good thing was I had a window and could crawl out on the roof [of the south addition]. They had these drainpipes. I could crawl down."

Ross and one of Burr and Peg's granddaughters, Robbin Polivka, have warm memories of spending time at Robbinswood with "Bama" and "Bompa," the names that Robbin's brother, Charles Rowley, bestowed on them when he was learning to speak.

These undated photographs of the main house show what it looked like when Fred B. Jones was alive and include many of the items that were auctioned off after Jones's death.
Courtesy of John Hime

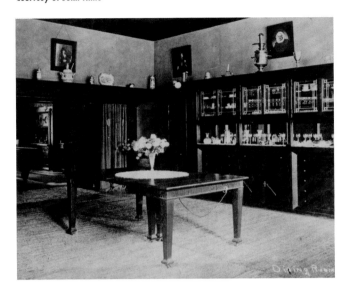

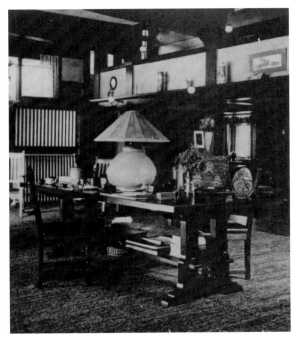

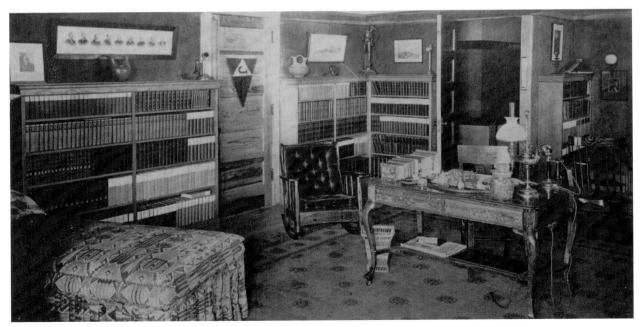

Peg and Ross Robbins in
the dining room at the
estate the family called
Robbinswood
Courtesy of Ross Robbins

Burr and Peg continued Jones's tradition of sharing Robbinswood Lodge with social and business guests. Their biggest summer social events were annual Fourth of July and Labor Day parties. Frequent and important business guests came from as far away as Indiana and Michigan. One was an executive with Chevrolet, another with automotive parts manufacturer Borg-Warner, and a third was dean of the business school at the University of Notre Dame.

"I can remember lots of activity down here," Ross says, gazing around the living room. Burr had a Steinway piano near the fireplace. "He'd play, he'd sing. Popular stuff. My parents, being in the advertising business, [had] friends and customers [come] up. What I remember about the property [is] it was a wonderful place to have a party. The living room, the size, the piano, having a band, some music in the corner by the fireplace. The flow of people through there really worked . . . , and the porch and the little library, now taken up by a billiard table."[4]

A professional photographer from Burr's company sometimes photographed the Labor Day parties. Two color photos show Burr, in a white suit, entertaining male business associates, probably in the 1950s. Other professional-quality photos of the family and of the estate found in a family album were taken by one of the guests, the advertising director for General Motors. Burr and Peg also hired professional photographers to capture images of family and friends.

Ross continues, "The dining room was pretty spectacular when we had parties. I loved that, and I loved the [front] porch, but the dining room was the focus point." The dining room looked starkly different during this era than it had when Jones entertained there, because Burr and Peg had painted the dark

Burr Robbins, standing at center, entertains friends on
the front porch.
Courtesy of Virginia Gerst

woodwork, including the large buffet, white. In addition, they covered the two west windows in the expansive living room with large mirrors.

Ross remembers sneaking along the balcony overlooking the living room to watch the goings-on. "Labor Day, the same people came up for thirty years. There were lots of meetings, lots of activity. The liquor always flowed there freely. There was a fair amount of wine and whiskey, but they were not alcoholics." A favorite drink, the "Robbinswood Special," was served in a monogrammed loving cup. It was a concoction of Champagne, Cointreau, gin, and lemon juice.

In addition to social and business entertainment, the Delavan Lake Improvement Association met monthly in season at Robbinswood Lodge. "They would keep the political contacts going, so things would be zoned properly around the lake," explains Ross.

Burr Robbins, standing at right, beams as he looks down at his daughter, Terry, during a gathering of guests around the Steinway piano in the living room. *Courtesy of Ross Robbins*

Burr Robbins, with one of his beloved German shepherds staying close to his chair, entertains the top officers of his General Outdoor Advertising Company, probably in the 1950s. The dinner was an annual affair. The dining room woodwork, including the Wright-designed hutch, had been painted white by this time. Glass cups filled with cigarettes are around the table. *Courtesy of Ross Robbins*

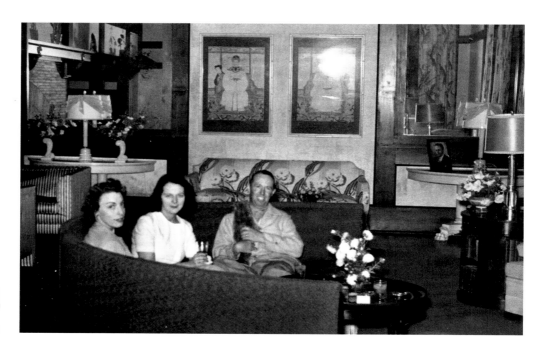

Peg (at center) and Burr Robbins covered the west living room windows with large mirrors.
Courtesy of Ross Robbins

As a child, Ross was fascinated by the Pavilion tower, where Jones and his friends had played cards. He remembers the small porcelain urinal built into the wall and hidden behind a door, and the round poker table. Unlike Jones, however, the Robbins family and their guests did not use the tower card room. "It stood there empty," he says.

Entertaining was facilitated by the presence of full-time help. "In those days you had cooks, chauffeurs, caretakers. It was the thirties and forties—you could afford that." The staff included upstairs and downstairs maids, a chauffeur, a cook, and a gardener/caretaker. The latter lived in the gate lodge, the others in rooms on the first floor of the east addition to the house.

When the Robbinses were not entertaining, they gathered in the library/family room rather than in the much larger living room. When asked for his favorite memory of the house, Ross focuses on the family room. "We would sit a lot at a little card table and play gin rummy, have a fire going, with family. That's a fond memory. We'd eat there a lot. We had two couches along the window and a card table by the fireplace. That's where we congregated."[5] A photograph from August 1941 shows Terry and Ross on the family room floor, in pajamas and bathrobes, reading the comics in the *Chicago Sunday Tribune*. Another shows two somber male guests, one with a cup of coffee and a cigarette in his left hand, reading the *Tribune* news sections. Jones had converted the safe room behind the billiard room liquor cabinet into a powder room around 1931.

Ross was certain that Jones had hidden a "secret treasure" there, and he and Terry were determined to find it. "We kept looking!"[6]

The downstairs—dining room, living room, and family room—were so much the focus of life in the big house that Ross and Terry commissioned a model of the rooms for Burr and Peg's fiftieth wedding anniversary in 1975. It was like a dollhouse, Robbins remembers, with miniaturized versions of the furniture in their authentic colors and working lights, all surrounded by glass.

Robbin Polivka does not hesitate when asked what Robbinswood Lodge meant to her. "Family, it was all family. As a child, spending time with my grandparents. It wasn't anything about the house, it was just being together. Three generations on the property, and that was so cool. My friends loved to come over. Too bad we can't all live that way. I think it's a lost way of being."

"During the summer, my grandparents usually opened the big house in April. They would stay at the big house throughout the summer, and then it was closed usually in October. During the winter if they wanted to come up [to the lake] they stayed at my mother's at the gate lodge. . . .

The Robbins family repurposed the billiard room as a family and breakfast room. The Adlake water spigot that Jones had mounted in the wall is visible at center between the curtains and the liquor cabinet. *Courtesy of Ross Robbins*

Terry and Ross Robbins read the *Chicago Sunday Tribune*'s comics in their pajamas while news of the war in Europe dominates the front page, August 1941. *Courtesy of Ross Robbins*

We all loved staying at the big house. It was always special to stay there. I used to spend a lot of time with my grandparents.

"We had family dinners virtually every Sunday during the summer at the big house. The whole family came when we were growing up. The menu varied with the week." Meals invariably included tomatoes, beets, peas, or string beans from the small garden near the stable. The vegetables were picked by Patrick and Julia Hale, the caretakers. They would also pick gladiolas that Peg would cut and arrange on the "hunter's table," a narrow, semicircular table near the built-in bench in the study.

She says that her mother used to mention two favorite memories of growing up at Robbinswood Lodge. "She talked about the parties and sailing. My uncle [Ross] and mother [Terry] both sailed. The trophies were displayed on the mantel of the study and . . . life was a breeze. It was very carefree." Ross remembers, "I sailed often. Sunday morning we'd race the [very fast] E-boats. There was a lot of camaraderie."

Burr kept his riding horses at his nearby farms, so he primarily used the stable for his dogs. He was president of the German Shepherd Club of America and raised several litters at Penwern. His beloved dogs often kept him company when he cooked steaks on the stone hearth in the

Burr Robbins, accompanied by one of his German shepherds, lights a fire in the picnic grove east of the main house. One of the two swinging iron gates thought to have been designed by Wright is seen at left. Courtesy of Ross Robbins

picnic grove east of the house. "Old Joe," a handyman, occupied an upstairs bedroom in the stable. "He was just a character," says Ross Robbins. "I used to admire him, because when he ate his food he chopped everything up and put it together. So, I sat down to our fancy dinner at our big table. They brought up the potatoes. I chopped up everything and started putting it together. I only did it once. I said, 'Old Joe does it.' I was told, 'No, you can't do that.'"

Several features of the estate memorable to Ross no longer exist. One is the picnic grove. A house was built in its place when that part of the estate was sold in 1989.

Distinctive iron gates at the east and west ends of the property, possibly designed by Wright, were also lost when

the lots at each end of the property were sold. Each gate had a steel pipe down the center, with a gate fastened to the post. The gates pivoted from the center. Chains swung the gates closed after they had been opened.[7]

"They were wonderful," Ross remembers. "They were like one structure on a single pole, and as you went through it, the chains would lift it up and open it up and then it would automatically come down. The gate would actually rise a little bit, and its weight would shut it. That was a marvelous little structure. They were wood with planks and open space between the planks. Very simple, but quite remarkable."

Ross also remembers the estate's flagpole, which had been delivered to Jones by train from Chicago. Located between the front porch and the boathouse, it was surrounded by a white wood bench wide enough to sit on. His children enjoyed helping to raise the flag.

The 12,000-gallon board-and-batten water tower (torn down after 1989) stood close to the west property line near the stable. Ross and his friends climbed a ladder to reach the play area they had fashioned in the tower ("tricky, a little dangerous, and hard to get to"). Polivka says that

Ross Robbins, family members, and a guest hoist the flag in 1979 on the flagpole that Fred B. Jones had erected between the front porch and the boathouse.
Courtesy of Robbin Polivka

she and her siblings were not allowed in it for safety reasons. They went anyway and her sister, Marca, fell, breaking her leg.

The boathouse was set afire early September 2, 1978, by a teenaged arsonist who likely had arrived by boat. Burr and Peg were at the house at the time; Ross saw the flames from his house nearby. He recalls, "It was burned down, gone. We were surprised, shocked." The stone and masonry foundation was intact after the fire, but the deck and upper part of the structure were too damaged to save. The Robbins family rebuilt the boathouse deck, and Ross later hosted his fiftieth birthday party and an Episcopal Church service there.

On winter weekends, the family stayed in Penwern's gate lodge with Tommy and Marie Searles, Penwern's gardeners and caretakers who lived there year-round, Ross says. "They were a wonderful couple. He was English, a character, played the horses. Marie was everything you

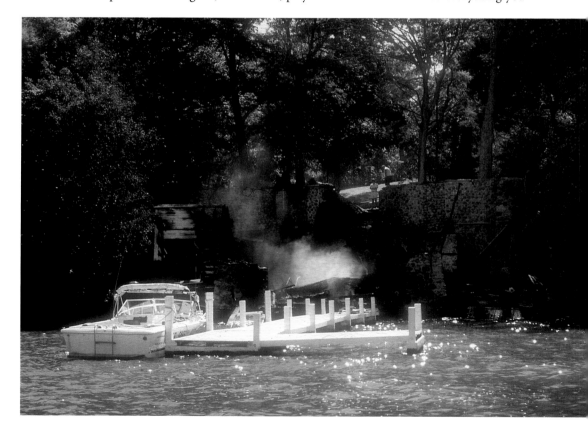

The boathouse ruins smolder after a pre-dawn arson fire in September 1978. Allen Buzzell, a longtime member of the Town of Delavan Fire Department, took the photo.
Courtesy of Allen Buzzell

wanted her to be, a cook, a caretaker. They were friends, not just servants." The gate lodge is compact, but with four bedrooms upstairs, there was room for both families there.

Ross had followed his father into the billboard business in Rockford, Illinois. He commuted to work from the lake for twenty years, first from his grandparents' house near the Jones estate and then from Robbinswood. The main house had not been put on the market after Burr's death in 1980, and Ross, then a bachelor, bought the house, the stable, and the boathouse from

STATE AND NATIONAL REGISTERS OF HISTORIC PLACES

It was during the Robbins family's stewardship of Penwern that the property was added to the National Register of Historic Places. The nomination was initiated by James Morton Smith, the director and first state historic preservation officer of the State Historical Society (now the Wisconsin Historical Society), charged with identifying state sites of historic importance.[1] In the nomination, historic preservation office staff referred to Penwern as "one of few structures Wright designed with undisguised Japanese details."

The nomination form's description of Penwern's "present and original physical appearance" provided additional detail:

The Fred B. Jones estate consists of a main house, gate house, boat house, and a barn with stables. All are extant and in good condition. All structures have fieldstone foundations and wood frame superstructures. Fieldstone was also used in a foot bridge which exists on the grounds.

The gatehouse sits directly on South Shore Road. It is sheathed with board-and-batten siding. The rather sharply pitched, shingled roof is the building's most distinguishing feature, for it continues across the driveway to connect with a two-story rectangular tower. Over the gatehouse the roof is broken by two Gothic-like dormers which are linked by a low, flat-roofed dormer containing two, small rectangular windows. Each of the Gothic dormers has two pointed windows.

The main house is distinguished by broad arches spanning the front veranda and the porte-cochere. The latter connects the main block of the house with a structure similar to the gate house tower. The entire house is faced with board-and-batten

siding. The large veranda is surrounded by a low fieldstone wall decorated by urns. The interior space along the lakefront is taken up by the living room which features a large Roman fireplace. On the second story is a balcony that overlooks the first floor rooms. The house has been altered by the addition of several rooms.

The composition of the house is asymmetrical, but the barn is quite symmetrical. The stable doors are marked by a gable. Like the other structures, the siding is board and batten.

The boat house is situated so that only the roof rises above the lake bank. It has board and batten siding, and the same broad arch used in the main house is repeated on the lake facade. The roof has a strong Japanese feeling with its rising ridgepoles and flaring eaves.[2]

Penwern was added to the National Register on December 27, 1974, and to the State Register of Historic Places in 1989. The nomination file includes an update to the property's status noting that "The boat house was destroyed on September 2, 1978, in a fire set by an arsonist."

NOTES
1. Email from State Historic Preservation Officer Jim Draeger to the author, June 6, 2018.
2. National Register of Historic Places, *Jones, Fred B., Estate ("Penwern"),* Lake Delavan, Walworth County, Wisconsin, National Register #74000134.

his mother in 1983 for $264,000 ($650,000 today). "My mother was delighted," he says. When he entertained, the gatherings were more low key than when his parents were living there. Sometimes he hosted retreats for his church group. Peg Robbins still owned the gate lodge at this time, and Ross's sister, Terry, lived there during summers with her four children when they were younger. She was a full-time resident from 1976 until her death in 2000.[8]

Ross's wife, Irene, is a Scot and was familiar with fine nineteenth-century architecture that some suggest may have come to Frank Lloyd Wright's notice, including Charles Rennie Mackintosh's famous tea rooms in Glasgow. Still, she says it was overwhelming to see the house for the first time when Ross introduced her to it before their 1985 marriage. The house needed a lot of work. "There were cracks in the walls, and we needed to varnish the wood," she recalls. "Ross was a bachelor and didn't notice those things." But she told him, "I will keep it." They had a new roof put on the house and hired eight brothers to paint it.

Ross and Irene did not feel much pressure about the house being a Frank Lloyd Wright design. "It was a beautiful Frank Lloyd Wright home," he says, "but not in an intellectual way. We loved it and appreciated it, but it was more our home than a Frank Lloyd Wright. That was not our number 1 [priority]. I think my dad met him one time. [Wright] did not have the best reputation! We didn't promote that it was a Frank Lloyd Wright." Since the Robbins family's stewardship of Penwern predated the explosion of interest in Wright's work, they did not have many Wright tourists to contend with.

However, Ross's niece Robbin Polivka recalls photos taken by photographers to illustrate stories for articles in magazines and Chicago Sunday newspapers about Robbinswood Lodge as a Frank Lloyd Wright commission. She also remembers that people interested in Wright's work would stop by uninvited. "My mother wouldn't let them in, invariably saying, 'No, I'm just getting ready to leave. I'm sorry, I can't help you here.'"

One of the rooms in the additions to the main house was sometimes referred to as the "love nest" by the Robbins family.[9] They speculated about whether it had been used by Jones for trysts. The maids' quarters had high windows, perhaps so the servants could not watch the comings and goings of guests.[10] Polivka was initially dismayed when Sue and John Major removed the 1909 and 1910 additions to the house. "That was part of the house," she explains. "That hurt. I have fond memories of a lot of the parts that they pulled off the house." She put the "hurt" in perspective after learning more about the history of the house: "We didn't know it wasn't part of the original house. To the family, the two additions were part of Robbinswood, with memories made in those places. [The] Majors are [re-creating] the original that was built. It looks beautiful! It just isn't Robbinswood anymore. It is Penwern now."

Terry Robbins's three children—Charles Rowley (left), Robbin Rowley Polivka (center), and Marca Rowley (right)—celebrate Christmas in 1987 in the family room fashioned out of the back porch of the gate lodge.
Courtesy of Robbin Polivka

Polivka remembers the lower siding on the house as a "deep woodsy" color, or "balsam green." Her brother, Charles Rowley, speculates about Burr's decision to paint the house that color rather than keep the lighter original shade. "I believe my grandfather wanted to establish his identity with the house. My great-grandparents, Bompa's folks, had a house about a dozen houses east of Robbinswood, in fact, next to another Frank Lloyd Wright, the Vanderwicken house [originally known as the Ross House]. Since this was Bompa's new country home, he felt the need to establish his own identity and had the house painted in the green and white that was to remain until the Majors purchased the home."[11]

Peg Robbins enjoyed coming back to Robbinswood Lodge for visits and asked daughter-in-law Irene to promise her that she would never sell it. The promise was hard to keep. Ross and Irene also had a home near Chicago, where they often got calls that the burglar alarm was going off at Robbinswood Lodge. Finally, the house and its attendant responsibilities were too much, says Irene: "Just remember what a big house that is. I did it for four years. Then I said, 'It just won't work for us.' You learned how difficult it was when you didn't have all the help. We would

work all week, scrub floors, it was never-ending." Ross adds, "It was a lot of expense. When I sold Robbinswood, Penwern, I was in a [relatively] new marriage." Ross and Irene put all but the gate lodge on the market in 1988 and sold in 1989 to John O'Shea.

Polivka was disheartened when her uncle sold Robbinswood Lodge. "I was very sad to see the property broken," she remembers. "It just kind of signaled an end to the way it had been. We spent the Fourth of July at the gate lodge every year my mother lived there. All four siblings came with their families. Uncle Ross had to do what was right for him, but that was the heartbreak, it was the beginning of the end of the Robbinswood we grew up in. Everybody went their own way. After my mother passed and we sold the gate lodge, I was thrilled that the Majors bought it. I was glad to see the property go back to a single unit and see the work go into it that they did."

Penwern had been on the market less than a year when John O'Shea bought it. Says Ross Robbins, "I wasn't asking a lot of money. I think we sold it for around $850,000 [$1,680,000]. That was a lot more than I had paid for it. It was a pretty good deal for him."

Robbins dismisses a local rumor that he would sometimes be seen walking the property after he sold it. He dismisses the notion, saying, "I was in a whole new scenario. I was pretty much on overload in my new life. I couldn't get into that reminiscing and walking the old property. Maybe my spirit was walking there, but physically, I wasn't there."

As he reflects on his family's fifty-year history with the estate, he is asked if he misses it. "I've been there, I've had it. I have a lot of good memories. Do I pine to own it? Nooooo way!"

John O'Shea (1989–1994)

Few people live in one Frank Lloyd Wright house in their lifetime, much less two, but John O'Shea moved from one Wright home on Delavan Lake to another when he bought Penwern.

As O'Shea sits on Penwern's front porch overlooking the lake on a pleasant summer afternoon, he reflects on his stewardship of the house and estate. He had enjoyed living in Wallis–GoodSmith House, four lots west of Penwern. He had restored it with the help of architect Brian Spencer. "Of all the homes I've had on the lake, Wallis was by far my favorite house. The feel of it. It was a manageable house." O'Shea cast aside sentiment when looking at houses. He was not attracted to either Wright house because of its architectural pedigree. "It was more the real estate potential," he explains.[12]

The Wallis–GoodSmith House, which O'Shea had bought in 1987, was his third lake house. "When the market and the economy went the way it should go, I'd buy [a house], fix it, and sell it. I bought [Wallis–GoodSmith], and we started to fix it up. This one had been on the market

quite a while. I heard that the owner was anxious to get rid of it, so I bought it and sold the one down there."

The Penwern property was about three acres larger when O'Shea bought it than it is today. He sold lots east and west of the house to Gordon D. Tracy, a developer from New Jersey, the day he closed on the property. "My intent from day one was to sell the two lots off. I had no interest in 545 feet of lakefront or the taxes."

His broker had found a single buyer for both lots. "It was nice," O'Shea recalls. "[Tracy] didn't build on them for a couple of years. I had use of the land." The tall water tower that Ross and Terry Robbins had enjoyed playing on was included in the sale; O'Shea would later tear it down.

Because Penwern was not yet heated well (and because O'Shea did not own the gate lodge so could not use it as winter quarters), the estate was solely a summer home for O'Shea. He enjoyed entertaining there, as Jones and the Robbinses had. He and his first wife, LuAnne, married a month after he bought Penwern and held their wedding reception at the estate on "a beautiful Saturday" after Labor Day. Some of the guests were stunned by the surroundings. Says O'Shea, "I remember one friend of LuAnne's came up to her and said, 'Someone told me this was your house. I thought it was a resort you rented out!' Most of my friends had been here already. They all thought it was a great party house."

O'Shea's favorite memory of the house is of a luau party with a reggae band that helped entertain two hundred guests. "As recently as two or three months ago," he recalls now, "somebody brought that up to me, [saying] 'That was the best party I've ever been to.'" The party was supposed to feature a pig roast, but someone had neglected to order the pig, so guests feasted on hundreds of hot dogs and bratwurst patties instead. Guests wore leis, and a banner with the word *Aloha* hung on the arch over the front porch.

O'Shea rebuilt the rotted front porch, replacing a straight outer wall with a curved wall to "put it back the way it should go." He remembers, "I had all the drawings, and I knew how it was supposed to be." To do the job, he hired Chris Olofson, a local contractor, "a real craftsman" with an affinity for Wright's architecture. "He had a hell of a time with some of it. Some of the lumber he would throw in the water and leave it overnight, so they could get the curved radius."

The work took almost a month. A game warden from the Wisconsin Department of Natural Resources challenged O'Shea about the work in response to a complaint from an unknown source: "'They said you're building this porch closer to the lake and you can't do that.' I got the book [plans for the house] and showed them, 'It's in the original drawing.' They got in their car, and they went away."

A deck built over the ruins of the boathouse by the Robbins family was the setting for John O'Shea's wedding reception in 1989, the year he became the fourth steward of Penwern. *Courtesy of John O'Shea*

One of O'Shea's favorite memories of his time at Penwern is the luau party he hosted for friends in 1993. *Courtesy of John O'Shea*

The Majors were experienced in renovating houses and had asked to see the house specifically because they had heard it needed work. And Penwern in 1992 could accurately be called a fixer-upper. The floors were out of plumb. The living room, one of the signature features of the house, was very dark because the west windows were covered by the large mirrors installed by Burr and Peg Robbins. The woodwork in the dining room had been painted. There were abundant signs of chipmunks and mice inside. And if those were not enough challenges, the boathouse had been burned down to its foundation. Their intent? "Simple . . . make it livable, make it look as it did when it was built," says John.

In its favor, Penwern was just five houses away from a friend's house. And, significantly, it had what John calls "great bones; lots to work with." He elaborates, "The rest is just paint and woodwork. So what that the kitchen was a pit? The other thing, it was on a great piece of property. Why buy a house with great bones if it is not on a great piece of property? [Today] they build lake houses that are ten feet apart."

One of Sue and John Major's first significant tasks was to remove Fred B. Jones's two additions to the main house. The one seen at center left, on the south side of the house, was visible to visitors as they came down the driveway. The demolition was completed in less than a week. *Courtesy of Sue and John Major*

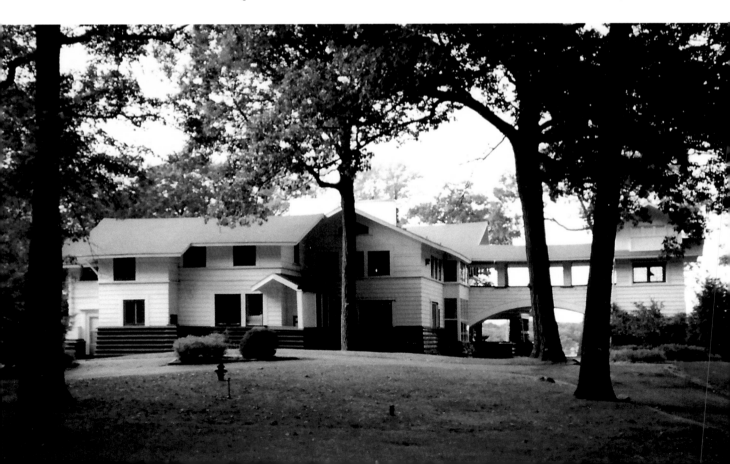

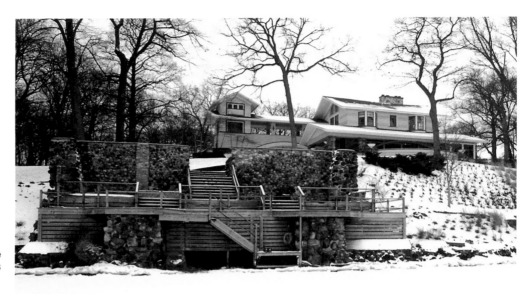

Fortunately for Penwern's architectural integrity, there was enough left in the ruins of the boathouse to spur the Majors to rebuild it. *Courtesy of Bill Orkild*

Sue recalls, "When we saw it, we had no idea of the significance of the architecture and what it would entail to renovate." Penwern's pedigree as a Frank Lloyd Wright design was inconsequential to them. "I was not impressed with Wright at all at this point, as [the estate] was in such bad shape. I loved the land it was on." The spectacular site trumped the reality of what she called "a grand challenge."

O'Shea had left copies of the surviving Wright drawings of Penwern for them. They did not realize that the 1909 and 1910 additions were not original until they saw the drawings for the first time, after they had bought the estate. They were taken aback when they realized the extent of the alterations and deterioration of the four buildings. Wright's drawings became their "bible."

The state of the boathouse was neither a deterrent to buying the property nor a priority to remedy. Says Sue more than twenty years later, "I didn't think about the boathouse initially at all because there were so many other projects to do first." John concurs. "It was much later that we realized that replacing it was essential to restoring the overall look of Wright's amazing work with the four structures in harmony."

John Major is generous when he talks about the previous owners: "The stewardship prior to John [O'Shea] must have been pretty good because there was something to save. [And] O'Shea deserves some fair credit. It's little recognized how much John contributed to the whole process. He got the restoration process going. One example was putting in some of the forced-air heating. The best example is putting in the curved wall on the front porch."

Homeowners who undertake the rehabilitation of a historic house that has been substantially altered must decide what period to restore it to. The Majors chose 1900, the year the house was designed, but with some updates, such as modernizing the kitchen and rebuilding and repurposing the original covered (but open) south porch into a year-round family room.

Neighbors were angry about the Majors' decision to remove Jones's two additions to the house, John says. "The whole community was upset. We got stopped in the supermarket. Everyone was angry. Nobody had ever seen the house the way it was intended to be built. Everyone assumed we were tearing down this Frank Lloyd Wright house."

While there is no documentation to prove who designed the additions, John agrees that it was not Frank Lloyd Wright. "Why would Wright design an addition? He has to take that incredible window in the dining room and cover it with a room. I would do that in the dead of night."

While it is unlikely that the parcels of land sold by John O'Shea will ever be part of Penwern, Sue Major says, "The estate is almost whole again, and most of the restoration is finished. I think every year we like it more and more because everything works, and it's so much less stress. I love it. I love coming here and having everything work."

The rehabilitation of Penwern has been a partnership between the Majors. John gives credit to Sue. "It truly is her house. She found it. It was her vision to restore it to its roots. I've frankly just been sort of helping implement that vision. If she says she wants the safe room, there is some detail in talking to the contractor."

Sue interjects, "[John] is an engineer. He is much better at being able to conceptualize. He is really good with Bill [Orkild, their contractor] and making decisions, all kinds of decisions that are infrastructure related."

John credits her again: "You come up with the concept, and I'm the little worker bee."

Wright homeowners are used to having people stop by unannounced during their quest to see the architect's buildings. It is not a common occurrence for the Majors, but they do not mind, John says. "We don't find it annoying. If anything, I get a positive view. If they enjoy it, I enjoy it. They're not making my life smaller."

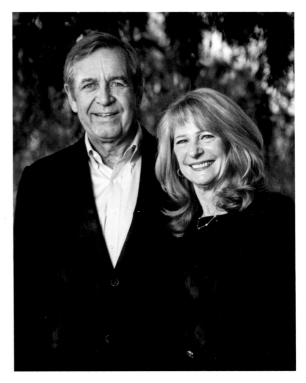

A quarter-century has passed since the Majors began restoring Penwern to Frank Lloyd Wright's original vision of a summer estate for his businessman client, Fred B. Jones. *San Diego Tribune*/ZUMA Press

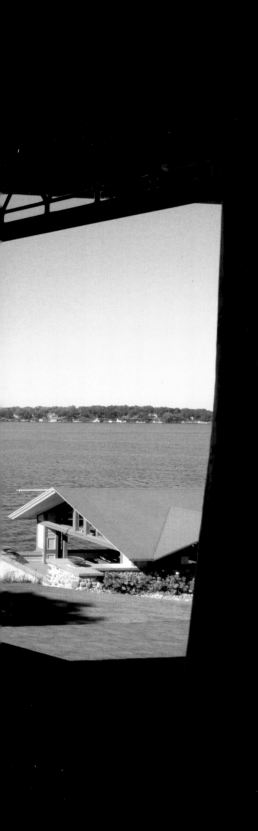

Restoring Penwern

4

Penwern was ninety years old when John and Sue Major bought the main house, boathouse, and stable in 1994. Their purchase was the beginning of an adventure that has resulted in the estate being restored to Jones's and Wright's shared 1900 vision and achieving National Register status.

Most of the Majors' restoration work has been done by Copenhagen Construction, owned by Bill Orkild. A home-printed flyer advertising Orkild's home repair services in Barrington, Illinois, where the Majors lived at the time, led him to Penwern.[1] "I made them [the flyers] as cheaply as I could. I put them in some mailboxes to see if anyone would call." He soon got a call from the Majors to repair a window screen. A week later, their assistant, Terry Koester, called to say that "John and Sue bought a weekend place and wondered if you have a week or two available for a couple of small projects."

That "week or two" has lasted twenty-five years. "When they said they had a couple of small projects in the fall of 1994, that's how it started—my half-of-one-cent investment in a flyer on a mailbox," Orkild says. "When my father heard about my working at Penwern, he said, 'That's not a job, that's a career.' Apparently, he wasn't too far off!"

Orkild thinks like an archaeologist. "Listen to the building," he says about his process. "The building will tell you what you want to

Fred B. Jones enjoyed this view of the boathouse and the lake from the master bedroom from 1901 to 1933.

Bill Orkild, right, has been the Majors' master of renovation, rehabilitation, and restoration almost from the beginning of their stewardship of Penwern in 1994.
Courtesy of Carol Schuler

know, if you take the time and let it. Too often people think they know how it should be, instead of letting the building answer the question for them." For example, he has detected marks in the stone foundation at the main house at Penwern that show where he believes the batten siding of the original porch walls was originally placed and where there once were steps down to the yard.

THE STABLE

Orkild's career at Penwern began at the stable. He gestures toward the stable floor and recalls, "This is somewhat representative of what the main house looked like in 1994: cracked plaster, tens of thousands of cracks in the plaster. . . . The floor here had a heavy dip. It was the same thing in the main house. All the floors had to be leveled, because they were so dramatically uneven."

The remains of four horse stalls could be seen behind the existing stable structure—evidence of the section of the building lost when John O'Shea sold the land west of Penwern and an access road was put in. A jagged roofline provided evidence of the demolition that happened when the estate was subdivided in 1989. One of Orkild's assignments was to rebuild the roof to Wright's specifications.

Walking across the concrete floor, which was poured in 3-foot strips, he describes the repair work, and then he climbs the stairs to the handyman's room, where "Old Joe" lived in the 1940s. Parts of the rotted stable had been open to the weather, and when Orkild began work, it was home to about a hundred raccoons. "Raccoon feces were at least 24 inches deep in the handyman's quarters," he recalls. "That alone was a project, just to clean it up and get the raccoons somewhere else they preferred. We weren't only sealing out the weather when doing repairs to this building, but we were trying to keep the wildlife out as well. Our main goal was to lock out the weather and lock out the rodents and ants. Anything in close contact with the ground

was rotted. Drainage was a big issue because it's built into the hill." As if the raccoons were not enough of a problem, there were also perhaps ten thousand bats in residence.[2]

The front of the stable was in particular disrepair. "It was completely rotted, completely gone," says Orkild. "Most of the structural work on the east side of the barn was essentially in collapse." Water ran back into the buildings because rubber technology to seal the building did not exist at the turn of the century. Orkild had to replace windows and build a new structural header because of extensive rot due, in part, to the flat roof above part of the stable.

Modern engineering, including steel I-beams, saved the stable when it was restored, Orkild says. "Wright's engineering left something to be desired. Wright designed the truss, and it failed miserably." His 2 x 6 studs, spaced 24 inches on center rather than 16 inches on center, were "not deep enough, not strong enough."

Orkild's first challenge at Penwern was to tackle the restoration of the dilapidated stable.
Courtesy of Bill Orkild

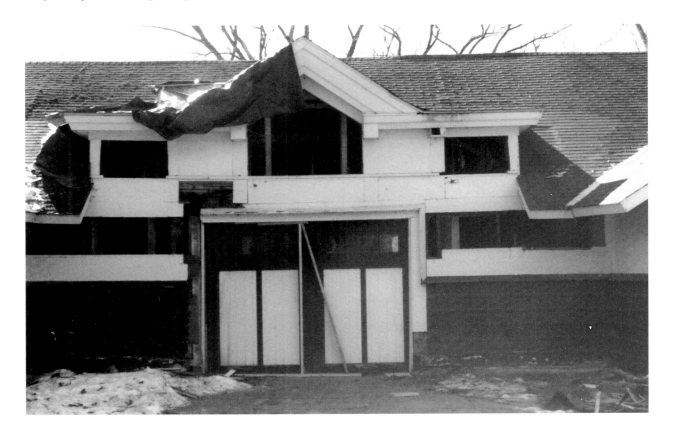

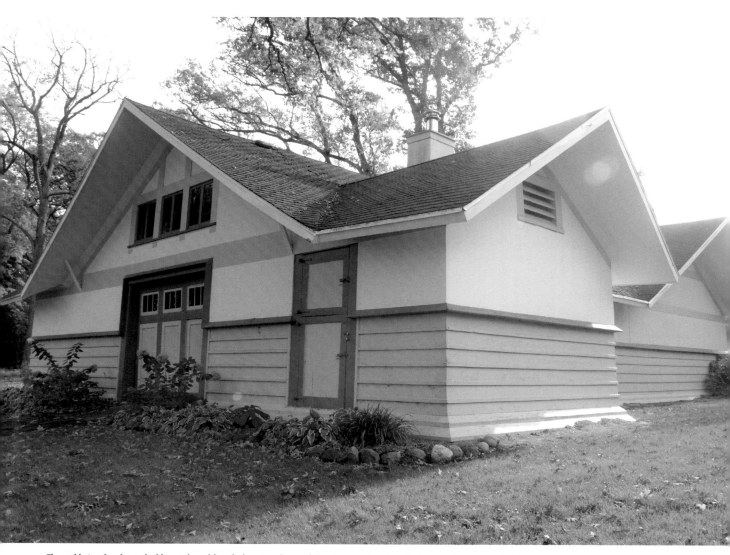

The stable is a handsome building today, although the original rear of the structure, including the horse paddocks, was lost in 1989 when land on the west edge of the property was sold. The Dutch door leads to the former icehouse.

UNDOING THE PAST

The removal of Jones's two unsightly additions to the house was a priority for the Majors. Contractor Chris Olofson, who had rebuilt the front porch with a curved wall for John O'Shea, was tearing down the additions when the new owners hired Orkild. Olofson was also repairing the roof and sagging eaves and jacking up the floors of the house. Orkild remembers the additions as "a bunch of small rooms [whose design] didn't relate to anything that was going on at the other end of the house."

The Majors significantly changed the kitchen area as well. Gone are the kitchen pantry and serving pantry. The "Man's Room" on the original plans (likely a bedroom for a servant) is now a breakfast nook. Orkild explains, "[Originally] that wasn't the important facade of the house. [But] the kitchen nowadays is such an integral part of the lifestyle of the homeowners. Some people have trouble [with] the way this room has been changed. My opinion is that a home has to adapt [to modern lifestyles] or it ceases to exist. I see nothing wrong with thoughtfully changing and having the home adapt to the current use and continuing to go on forever. If it

The former "Man's Room" near the original pantry and kitchen is now a breakfast nook.

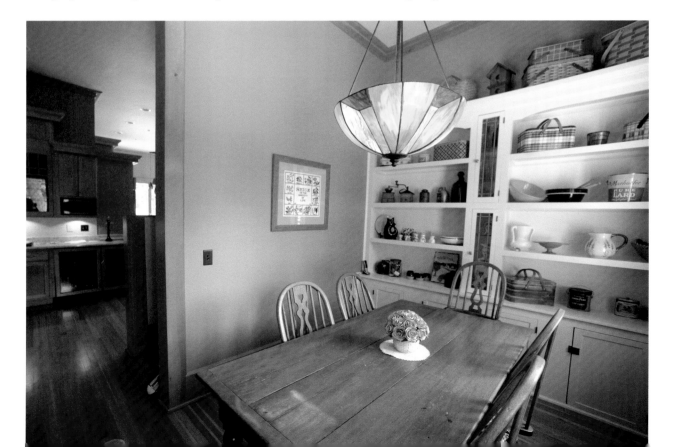

can't adapt, it can't continue to serve its purpose." He is particularly proud of the rich hues of the kitchen floor he installed. The wood is heart pine, from the center of old-growth pines and reclaimed from a former factory in the South. "As a tree ages and begins to die in the center, that's when it picks up hues of orange and red," Orkild notes.

The Majors had the upstairs bathroom facilities renovated to reflect changes in sensibilities about shared bathrooms. Penwern was constructed with one bathroom upstairs and a powder room near the front door. The upstairs bathroom had been divided into two bathrooms at an unknown date; Orkild restored them to a single bathroom by removing the dividing wall. He then fashioned bathrooms out of two upstairs bedroom closets, including one in the master bedroom. John Major recalls that the bathroom remodeling projects restored a window that had previously been covered by a bathroom added to the south bedroom. He says that with that change, the bedroom is now spectacular.[3]

THE LEGEND OF THE SAFE ROOM

Olofson was leveling the floors from the basement in 1995, Orkild says, when one morning he found the liquor cabinet, which sat on casters, sitting a few inches from where it had been the evening before. He pushed it back in place. The next night it rolled even farther out, perhaps

The dining room and billiard room are visible from inside the powder room that Fred B. Jones had fashioned out of the safe room in 1931. This photograph was taken when the space was being restored in 2013. The door that Jones had installed in 1931 was walled off; access to the space is from behind the rolling liquor cabinet, at right, as it was in 1901.

10 inches. Olofson rolled it out completely and found a 1 × 6 tongue-and-groove door behind it that opened to the powder room, which was customarily accessed through a door adjacent to the billiard room fireplace. The hidden door, which had a lock on it, was in an unpainted plaster wall, unfinished at the bottom.[4]

The room was not originally a bathroom. One of the modern legends of Penwern is that Fred Jones had a "safe room" where he hid liquor during Prohibition. There was, indeed, a safe room hidden behind the billiard room, but it was not for stashing illegal liquor. Wright's plans specify a zinc floor plate under the room, leading Orkild to conclude that the "safe room" was literally that, a room containing a safe in which Jones could keep cash, jewelry, and important papers. Wright's drawings even refer to the casters under the liquor cabinet.

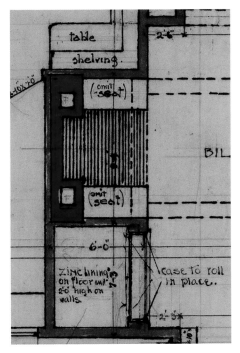

Frank Lloyd Wright's September 1900 plans call for a zinc lining for the safe room floor and specify that the liquor cabinet was to be on casters. It is unknown whether the inglenooks on either side of the billiard room fireplace were originally built with seats.

The liquor cabinet easily rolls away from the wall, revealing the door behind it. While it once rolled forward on casters, they left marks on the floor. Orkild redesigned it so it now rotates on a large hinge and no wheels touch the floor.

Jones converted the small room into a powder room in 1931; a plumber's drawing from that era was nailed to the back of the door behind the liquor cabinet. A low-voltage wire in the room ran a bell system that enabled Jones to summon servants. When restoring the safe room, Orkild designed a hinge to allow the cabinet to move out without marring the floor.

THE GATE LODGE

The gate lodge also needed extensive work when the Majors bought it from Terry Robbins Canty's children in 2001. Some damage was due to water, and some had resulted from alterations made by Canty between 1976 and 2000.

Drainage around the gate lodge had long been a problem. Orkild says the 24-inch-deep foundation was dug by hand in 1903. (A sticker on a box of nails Orkild found in the gate lodge during restoration confirms newspaper accounts that it was built in 1903: "Scott St. Works This Keg of Nails was Made Feb 1903.") After the driveway was paved much later, Orkild says, water would "flood into the driveway off South Shore Road, as a river," and into the basement, because it had nowhere else to go.

There are now two and a half bathrooms in the gate lodge. A contractor had cut through a roof support when Canty added one on the landing at the top of the stairs. She also enclosed the back porch. Holes had been "chopped" in walls for air conditioners. The Majors have restored the porch and the damaged walls, commissioned extensive stucco repair, and had all the eaves rebuilt.

Cast iron waste lines coming from the upstairs bathrooms had rotted, allowing methane gas to escape. "It wasn't just the smell," Orkild says. "Methane gas is flammable; it wasn't optional [to repair]." They were replaced with modern plastic pipes, which necessitated removing and then rebuilding the living room ceiling below. Each piece of wood trim was marked and stored in the stable before being refinished and reinstalled.

Lines etched in the stones of the water tower and the remains of a semicircular stone wall show where the original greenhouse roof was braced in place. The greenhouse foundation, floor, and irrigation pipes were uncovered in October 2017. The greenhouse walls are now stored upstairs in the barn. The Majors plan to rebuild the greenhouse and the stone wall that once encircled it on one side.

The second greenhouse that Jones added on the west side of the gate lodge rose over the dining room windows, which could no longer be opened. Orkild removed both the second greenhouse and a carport that had been erected when the original (Wright-designed) greenhouse was taken down.

The restoration of the gate lodge included the removal of air-conditioning units and opening up the back porch again. *Courtesy of Bill Orkild*

Bill Orkild's work on the gate lodge restored it to Fred B. Jones's and Frank Lloyd Wright's 1903 vision. *Courtesy of Bill Orkild*

This view from the gate lodge porch into the dining room shows Wright's hutch. *Courtesy of Bill Orkild*

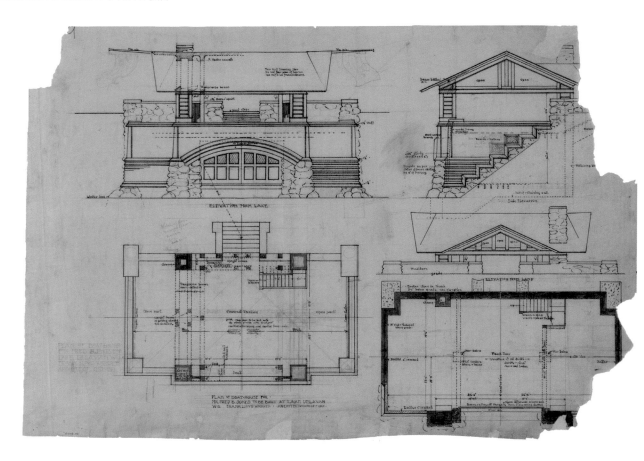

REBUILDING THE BOATHOUSE

The Majors' most celebrated rehabilitation project has been rebuilding the boathouse. At the time they bought the property, the remains of the boathouse had stood largely ignored for more than two decades, other than the addition of a deck by the Robbinses. The side walls had gaps in them larger than his fist, Orkild says.

Rather than replace the boathouse with a completely new one, the Majors sought to honor Wright by rebuilding his design on the existing foundation. Reconstruction would prove to be challenging in several ways. Orkild shows a copy of Wright's 1900 plans, a single page with four small drawings of the structure including two floor plans: "That was it."

Perhaps the biggest obstacle was a one-page letter from Walworth County zoning officer Nancy D. Welch on November 29, 2001, denying the Majors' zoning application. She determined that the boathouse did not conform to existing zoning ordinances and that since its use had been "discontinued" or "terminated" for more than twelve months, it could not be rebuilt.

By July 4, 2005, the Majors had a usable building, with a floor, a deck, and a staircase down to the pier. The remaining details were completed in the fall, a year after reconstruction began. The boathouse was rebuilt for the ages, Orkild says. "We anticipate no failure in the future because of the steel-reinforced concrete wall."

OTHER PROJECTS

When John O'Shea had the front porch reconstructed in 1989, it was rebuilt with a curved outer wall as Frank Lloyd Wright had indicated on his 1900 plans. But when the Majors took ownership, the two side porches still had straight walls. When Orkild rebuilt them, he also removed partitions that had evidently been added after the house was built. The porches now offer the sweeping sense of openness Wright had intended.

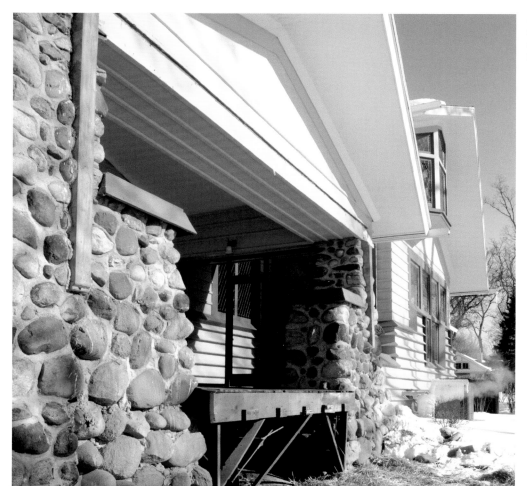

Bill Orkild's reconstruction of the side porches began in early 2015, well in advance of the summer season.

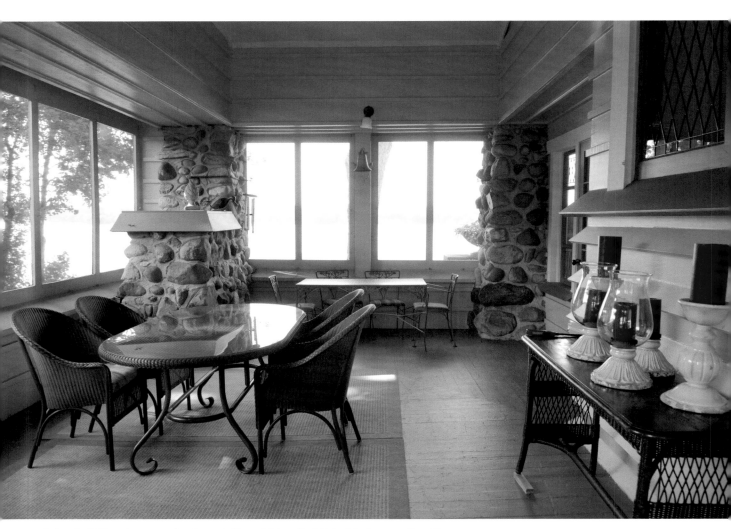

Before the 2015 porch reconstruction, the west side porch felt confined. Today it feels open to the outdoors.

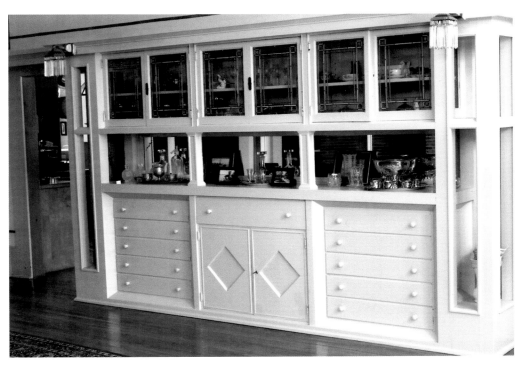

The dining room woodwork, including the magnificent hutch, had been painted white by the Robbinses. Bill Orkild painstakingly stripped and refinished it. *Courtesy of Bill Orkild*

Early photographs of Penwern are, of course, black and white. The original colors of the house have been identified by Orkild, who has a shoebox filled with paint samples. He believes rust is "the great lost color of Penwern," based on colors he has detected during his restoration work. The windows sashes in all four buildings were off-white, he says, and the gate lodge was likely green. He has found green paint samples, including pea green stucco, in the dirt. He believes the ceiling of the gate lodge was gold and that the servants' quarters in the main house were blue. The Majors selected light yellow with green trim for all four structures.

The windows and mirrors in the hutch were removed during Orkild's restoration of the piece in 2011. *Courtesy of Bill Orkild*

Burr and Peg Robbins had painted the woodwork in the dining room white, including the large hutch, ceiling beams, doors, and molding. The Majors asked Orkild to strip the paint and refinish the wood in 2011. It was "a winter project, a God-awful project," Sue says. John elaborates, "[The dining room] is big. It's got to be perfect. If you leave one little fleck, it will stand out from 10 feet away."

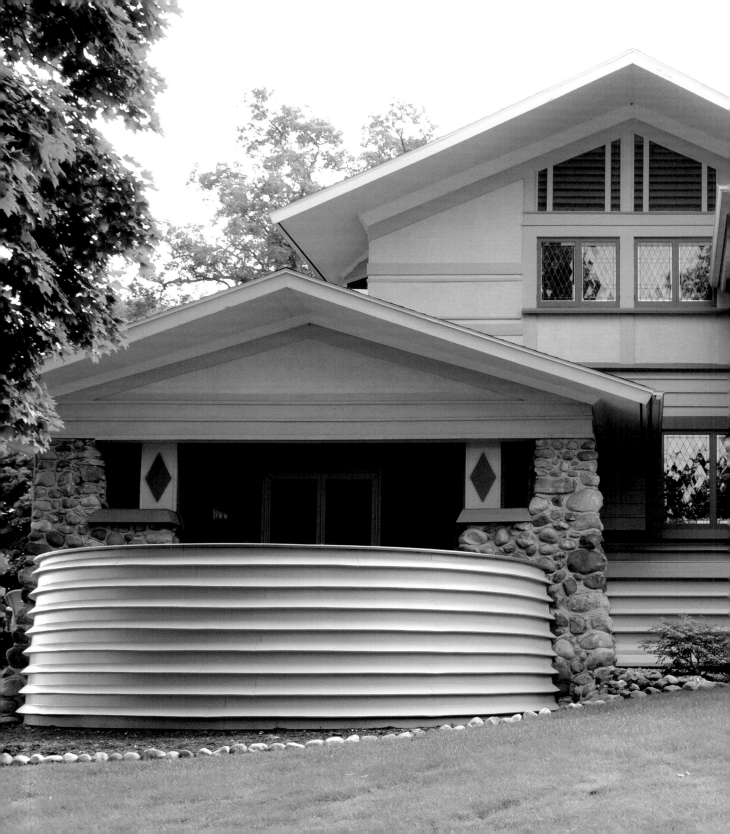

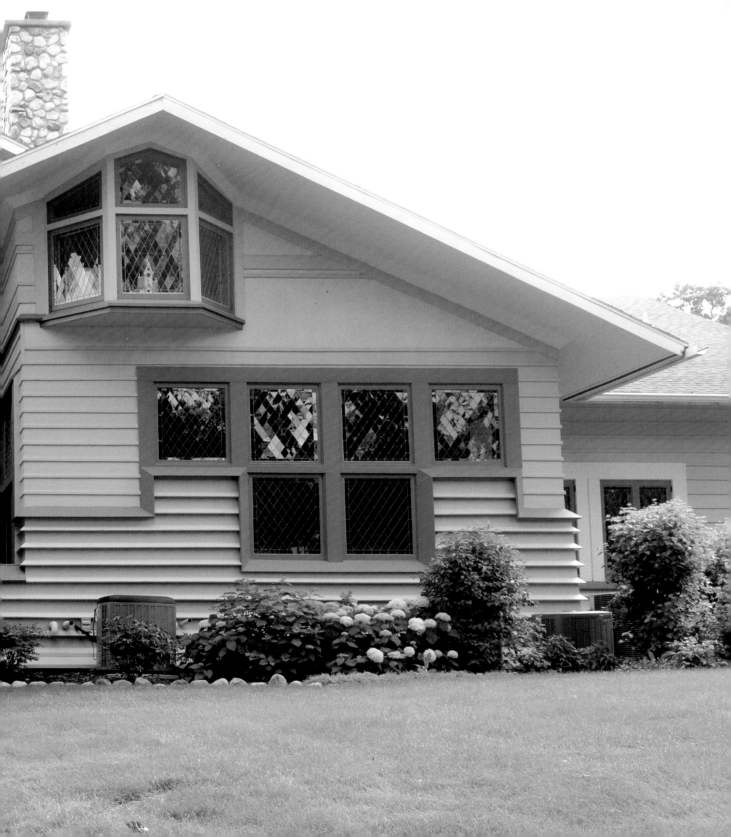

(previous spread)
The current exterior color scheme feels more in keeping with the surrounding landscape than the former stark white and green. The curved side porch walls provide a visual counterpoint to the broad eaves.

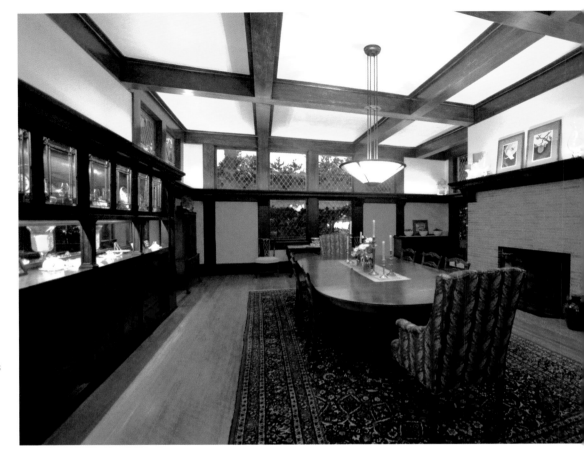

One can only imagine the myriad social and business conversations that have taken place in the dining room at Penwern since 1901. Today two dozen people can be seated for dinner in the main house.

The Robbinses had built a swimming pool just west of the house in the late 1960s. The Majors built a new one in its place in 2017. *Courtesy of Sue and John Major*

Some of the projects the Majors have taken on are less obvious. They include removing the basement mount for the gas generator that converted coal into gas to light the house when it was built. Some of the original gas lines and fixtures on the side porches are still visible.

The pump house south of the house was twice the size it is now. The portion that is still standing was built over a concrete foundation. The part that is gone was built over wood planks laid on dirt. There was apparently a family garbage dump west of the pump house, between the main house and the stable. Orkild has found broken china in a depression there.

Because Penwern is a cluster of four significant architect-designed structures, attention must be paid to the quality of its landscape. Orkild worked closely for many years with Jerry Gifford of Gifford Tree Service of Delavan. "We would walk around each fall and discuss each tree, what should be done." Gifford had worked at Penwern since the early 1950s, when he removed about one hundred trees that were suffering from Dutch elm disease. Until then, Orkild says, there was "dense forest," rather than a lawn, west of the gate lodge and south of the stable. He adds, "To the Majors' credit, they have agreed to a planting program. We add each fall a few trees to replace those we know have been lost. We are putting back in white oaks and sugar maples." He remembers a tree that had been struck by lightning and exploded. Wood shards, including "the equivalent of 4 x 4 post," were found on the north side of the Pavilion tower. "If that had hit the house, I'm confident the house would be lost."

Penwern estate is more than a collection of four buildings. Landscaping complements them and ties them together.

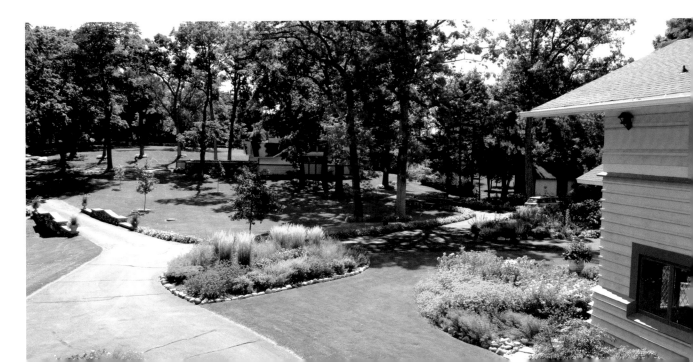

Robert Hartmann, left, interprets Frank Lloyd Wright's construction drawing of the stable for Bill Orkild as they compare the drawings to the extant structure.

A TEAM EFFORT

Orkild considers what he has learned from his experiences at Penwern. "Find something in your life worth doing, do it to the best of your ability, and don't stop until you're finished. In this case, they're still not finished, and we're [twenty-four] years into it!"

He pays tribute to his clients. "The Majors are pretty special people. They're willing to invest in you and put their trust in you. If you don't let someone do the best they can, and even go beyond their comfort zone, and maybe even make a mistake, they're never going to grow and become better at what they do. They've allowed me and others to be responsible. Take care of it. Get it done. 'I'm not going to tell you how to do it. I'm not going to stand over you.' They're pretty unique people in that way."

John Major, in turn, says that Orkild "thinks about this house all the time." The contractor's creativity and craftsmanship have led to the addition of a guest bathroom and a coat closet between the billiard room and the dining room and to the handsome inglenook benches flanking the billiard room fireplace.

Sue and John Major are the fifth stewards of Penwern. Perhaps Bill Orkild's name should be added with an asterisk. The collaboration among these three perfectionists led to the

The inglenook at the left of the billiard room fireplace hides the door Fred B. Jones had built when he converted the safe room behind the liquor cabinet into a powder room.

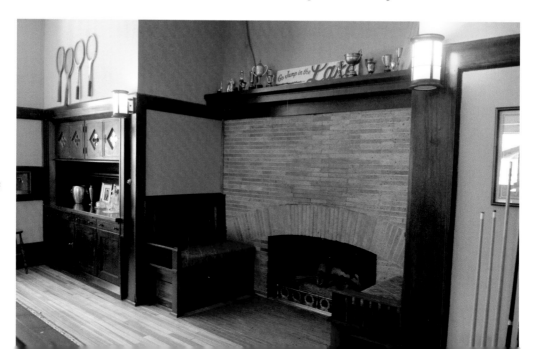

Majors' receiving the prestigious Wright Spirit Award from the Frank Lloyd Wright Building Conservancy in 2005. The honor, given annually since 1991, "recognizes efforts of extraordinary individuals and organizations that have preserved the legacy of Frank Lloyd Wright through their tireless dedication and persistent efforts." As recipients of the award, the Majors join other luminaries in the world of Wright preservation and advocacy.

THE NEXT GENERATION AT PENWERN

Sue and John Major's children, Barbara and John, have spent more than half their lives watching the repair projects unfold. They will be the next stewards of Penwern. When John (the father) is asked what the children think of having parents who are stewards of a Wright home, he replies, "They get it. The way you find out what your kids think of their houses, when they have a friend over, [and you hear what they say]. When they have their friends here, they can give the tour better than Sue can." Sue adds, "They appreciate it more and more."

Two generations of the Major family—John, Sue, Barbara, and John—have experienced the transformation of the estate back to Frank Lloyd Wright's and Fred B. Jones's vision.
Courtesy of Sue and John Major

(opposite)
As the sun sets over Delavan Lake, it becomes clear why the porch on the far side of the house is considered the "front" porch.
Courtesy of Sue and John Major

Barbara and John represent the future of Penwern. It can take time for people to realize the historic significance of a landmark owned by their parents. That was certainly true for the Majors' children. "Before it was Penwern, it was just the place I went every summer, and over the course of my life, watching my parents put time into it and restoring it, you realize there's more significance to it. It is where the vast majority of childhood memories with my family were made," says John (the son).[13]

He had no sense of Wright's or Penwern's significance when his parents became stewards of the estate. But that soon changed. "Hoping I would understand its significance, they pushed me to do every [school] report on Frank Lloyd Wright." Another turning point in his appreciation of Penwern and of his parents' rehabilitation of the estate came when he took friends and colleagues there as an adult. He couldn't help but notice their reactions and become more interested himself, he says.

His plans for the future of Penwern are not complicated. "I think our priority will be just continuing going on the path our parents started us on, striving to keep it consistent with Frank Lloyd Wright's vision for the house, trying to keep it open and available for folks interested in his work, and also a great place for family and friends to get together and enjoy. . . . That's when you enjoy the house, when you take folks and take them around and are entertaining, that's the best way to experience the house." Earlier stewards Fred B. Jones, the Robbinses, and John O'Shea would agree.

The house has come full circle. Early in his stewardship of Penwern, John Major wrote, "The 'arch house' [as they called it before learning its rich pedigree] is as it was intended to be and the original and compelling genius of Frank Lloyd Wright is revealed." It is, indeed.

The Majors welcome fifth-grade students from Wakanda Elementary School in Menomonie, Wisconsin, in 2017 during their annual two-day bus trip exploring Frank Lloyd Wright's work across the state.

In addition to Penwern, four other Wright-designed cottages and the Delavan Yacht Club were built on Delavan Lake between 1900 and 1905. The structures have been altered to varying degrees from the original designs, and one was demolished. Wright also designed several unrealized Delavan Lake projects. All are included in Bruce Brooks Pfeiffer's works *Frank Lloyd Wright 1885–1916: The Complete Works* and *Frank Lloyd Wright 1943–1959: The Complete Works.* The four-digit Wright archive number and page number in the book follow the name and year of the commission.

Other Wright Designs Built on Delavan Lake

1900: Henry (and Minnie) Wallis Summer Cottage:

Scheme 1: 0006, p. 117

Scheme 2: 0114, p. 118

3407 South Shore Drive

The Wallises never lived in the house, selling it quickly to brothers Drs. Heber and William GoodSmith. It is now often known as the Wallis–GoodSmith House.[1] It has been written that Wallises did not live in the house because of the death of their only child, Sidonia, but she was born in 1903 and died in 1927.

The Wallises previously had a non-Wright residence at 3301 South Shore Drive. There is no documentation to prove it, but it is widely believed that Wright designed or remodeled

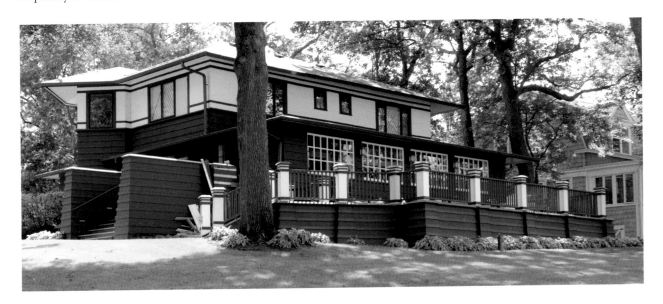

Wallis–GoodSmith House

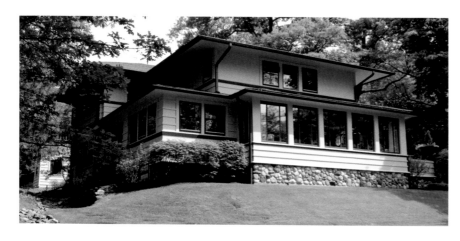

Clockwise from top:
Charles Ross Summerhouse,
George Spencer Summer
Cottage, Arthur P. Johnson
House, Wallis Gatehouse

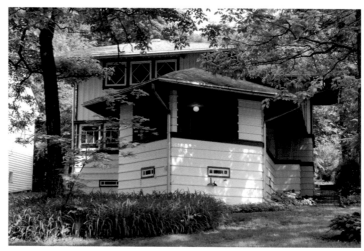

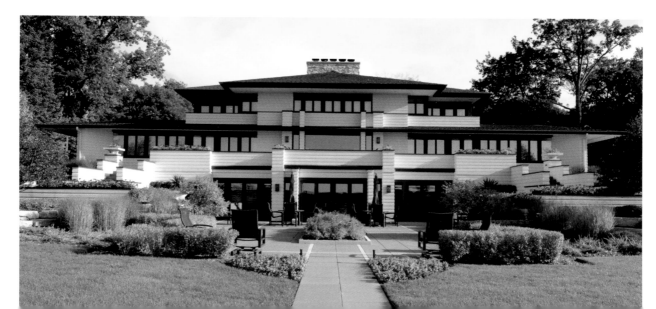

the Wallis Gatehouse at the entrance to the property in 1894 or 1897. Wright designed the boathouse in 1897. It was demolished prior to 1939.[2] Wright also designed a decorative sign for "Wallisia," the subdivision near that property (0109, p. 133), as well as a canvas deck chair with an awning.

1902: Charles (and Mary) Ross Summerhouse: 0206, p. 161

3211 South Shore Drive

1902: George (and Carrie) Spencer Summer Cottage: 0207, p. 162

3209 South Shore Drive
Summer home for the Rosses' daughter and son-in-law, adjoining Ross property.

1902: Delavan Lake Yacht Club: 0217, p. 145

604 Sutter Avenue (now DelMar Park)
Constructed in 1904, demolished in 1916.

1905: Arthur P. Johnson House: 0508, p. 225

3455 South Shore Drive
Unlike Wright's other Delavan Lake houses, which are board and batten, the original construction was tongue and groove.

Unrealized Commissions
1902: Lake Delavan Clubhouse: 0220, p. 145

There were four different proposals for this project, according to Pfeiffer (*Frank Lloyd Wright 1885–1916: The Complete Works*).

1902: Christian (or Chris) Wolf Cottage remodeling

The two weekly Delavan newspapers reported on October 23, 1902, that Chicagoan Wolf had purchased "the Lowell south shore place known as Tacky Teazie" and hired Wright to remodel it. No plans or other documentation have been found, nor has the house been found, if indeed it is still standing.

1907: Cottage for Lake Delavan: 0715, p. 294

There are conflicting captions on the three drawings for this project, wrote Pfeiffer (*Frank Lloyd Wright 1885–1916: The Complete Works*).

1913: Hotel on the site of The Log Cabin Resort

In 1913 there was a newspaper report that Wright had been retained to design a new steel-and-concrete hotel on the grounds of The Log Cabin resort on the North Shore of the lake.[3] It would accommodate four hundred guests. No further mention of the project has been found.

1945: John D. Stamm Home: 4513, p. 76

The handwritten "Delavan" notation on the drawing is an error. In fact, it was to be located on Lake Nagawicka near Delafield, Wisconsin, not Delavan.[4]

Acknowledgments

A book does not appear out of thin air. Behind the name of the author and photographer on the cover are dozens of people without whom this book would not have been possible. First, of course, I must thank Sue and John Major, the stewards of this magnificent estate since 1994, for entrusting me with the assignment of researching and telling the stories of Penwern and Fred B. Jones. None of us dreamed in April 2013 that this would be a five-year project! I thank them for their confidence in me and for their patience. They did not set a deadline for me, only insisting that I get it done right. The Majors called me thanks to Sara Buchen-Ray, a mutual acquaintance, who had given them one of my earlier books. "Do you think you could do a book for us like your Hardy House book?" asked Sue.

Sue's father, the late Frank W. Blackston, always greeted me with a smile and a story when I saw him on summer research and photography visits to Penwern. He is remembered by his favorite expression, "Knowledge is power; attitude is everything," on one of the upper walls of the dining room in the main house. I wish he could have seen the book.

The book began as a private commission to be published for the Majors' family and friends. I thank Jim Draeger, State Historic Preservation Officer with the Wisconsin Historical Society, and Kathy Borkowski and Kate Thompson of the Wisconsin Historical Society Press for their interest in the project, which evolved into a lovely book under their imprint. I especially appreciate Kate's stewardship of the project, including her thoughtful editing.

It was important for me to base this book on original research. As such, it contradicts some things that have been written in the past about Jones and about Penwern. My starting points were Joanna Broussard's initial research for the Majors and the research done by Denise Hice, Jack Holzhueter, and Traci Schnell for Wright in Wisconsin's Wright and Like tours.

Many, many people were generous with their time, agreeing to interviews in person and on the phone and answering emails. Those directly involved with Penwern include Burr and Peg Robbins's son, Ross, the third steward of Penwern; the Robbinses' grandchildren Robbin Polivka and Charles Rowley; John O'Shea, who followed Ross as steward of Penwern; and Bill Orkild, the Majors' master carpenter and contractor. Emily Smith graciously opened the house for me

when the Majors were not home. John Notz, an independent architectural historian and a long-time friend of Ross and Irene Robbins and of Sue and John Major, assisted me as well. Virginia Gerst, a friend of the Robbins family, provided historic photos.

Stewards of Wright's other homes on Delavan Lake were generous with their time when I interviewed them and photographed their houses: Dorrit Bern (Wallis–GoodSmith House); Jim and Holly Campbell (A. P. Johnson House); Don and Jean Clark (Ross House); Dick and Joan Gifford (who recently lived in the gate lodge at Penwern); and Bill and Mary Ann Mueller (Spencer Cottage). Richard Beers and his mother, Mary Waidner Beers, provided additional history about the Wallis–GoodSmith House and sailing activities on Delavan Lake. Betty Schacht, whose grandparents Carl and Gerda Nelson were caretakers of Penwern in the early 1930s, shared a wonderful family photo album of life at the gate lodge, where they lived.

The lack of Jones family records and of correspondence between Wright and his early clients posed a great challenge. Mary Stauffacher's help was invaluable as she turned genealogical sources inside out helping trace Jones's family. Kathleen Staffa, Jones's first cousin, twice removed, whose father was also named Fred Bennett Jones, helped with family history. Robert Bunn and Andrew Card helped with Frank Hatch Jones's history. George Ronald White, historian of the Chicago Athletic Association, was unrelenting in his quest to research Jones's history with this important club. Arthur Miller led me to the archived copies of *The Cherry Circle*, the club's magazine, at Lake Forest College, coincidentally my alma mater. Paul Sprague, professor emeritus of art history at the University of Wisconsin–Milwaukee, was generous with his time. Tom Coe helped with genealogical research.

I was unable to determine who delineated the surviving drawings of Penwern. Many people helped try to unravel the puzzle. They include Wright scholar Kathryn Smith; Celeste Adams and David Bagnall of the Frank Lloyd Wright Trust; Janet Parks, Nicole Richard, and Margaret Smithglass of the Avery Architectural and Fine Arts Library at Columbia University; and Professor Donald Leslie Johnson, Glenda Korporaal, and Professor Christopher Vernon, each corresponding from Australia. I thank Margo Stipe, Oskar Muñoz, and the late Bruce Brooks Pfeiffer, all of the Frank Lloyd Wright Foundation, for answering many questions about Wright's work on Delavan Lake.

A small group of friends comprise what I refer to as my "architectural brain trust" and answered myriad questions. They include designer Eric O'Malley (who also created the maps for the book) and architects and Wright scholars Randolph C. Henning; Patrick J. Mahoney, AIA; William Blair Scott Jr., Honorary AIA; and Brian A. Spencer, AIA; Wright archivist Douglas Steiner; and journalist and Wright scholar Ron McCrea. Robert Hartmann, a friend and an

architectural designer in Racine, gave unselfishly of his time as he has for all my books. He spotted the faint pencil lines on Wright's porch drawings for Penwern indicating that the outer walls should be curved lines, rather than straight. His keen eye also discerned important details on one of Wright's drawings for the Wallis Scheme 1 cottage. Julie L. Sloan and Rolf Achilles were resources for my research into the windows at Penwern.

Spencer, who worked on the Wallis–GoodSmith House and was the lead architect during the rebuilding of Penwern's boathouse, is particularly knowledgeable about Wright's history on Delavan Lake. He introduced me to William Michael Fox, whose parents were past stewards of the Wallis Gatehouse. Spencer also suggested I contact architect and author Thomas A. Heinz, AIA, for the possible derivation of the name *Penwern*.

Among his other important contributions to this manuscript, Jack Holzhueter introduced me to Georgia Lloyd Jones Snoke, Wright's first cousin, twice-removed, and her family. She and her husband, Kenneth, provided photos of the Pen-y-wern cottage in Wales and photos of Wright's maternal grandparents. Georgia Snoke also contributed a thoughtful essay about the ancestral home.

Libraries and historical societies are important resources for authors. In Illinois: Clari Dees at the Pittsfield Public Library for her painstaking research of microfilm copies of Pike County newspapers; Pittsfield Historical Society; Griggsville Historical Society; Jerseyville Public Library and Jersey County Historical Society; Chicago History Museum; Chicago Public Library; Ryerson and Burnham Archives of the Art Institute of Chicago; Highland Park Public Library; Historical Society of Oak Park and River Forest; and the Oak Park Public Library. In Wisconsin: the Delavan Historical Society and its repository of Gordon Yadon's files (particularly Sandra Soukup-Behn and Patti Mariscano); Pat Blackmer at the Walworth County Historical Society; Aram Public Library in Delavan for microfilm copies of the Delavan weekly newspapers; SC Johnson Frank Lloyd Wright Research Library; and the Wisconsin Historical Society. I also used resources of the National Library of Wales.

Vintage postcards were graciously shared by Randolph C. Henning, John Hime, Patrick J. Mahoney, Eric O'Malley, and Brian A. Spencer.

Delavan historians Allen Buzzell and the late John Buckles helped immensely with local history. Elisabeth Dunbar helped with research about Wright's Harlan B. Bradley and Warren Hickox Houses in Kankakee, Illinois. Peter Burnside provided letters written by his grandfather, Ward W. Willits, from Delavan Lake in 1895. David Michener of the University of Michigan lent his expertise in trying to identify the trees and other plantings native to Penwern's grounds. Mike Rzeszutko, Randy Schneider, and Matt Stuch at Adams & Westlake researched questions about the company.

38. "Henry H. Wallis, A Resident Here All His Life, Is Dead," *Oak Park* (Illinois) *Oak Leaves* newspaper, March 2, 1933.

39. Brian A. Spencer, AIA, emails to the author, July 10, 2015, and January 10, 2017. Spencer, a Wright scholar and the architect who supervised reconstruction of the Penwern boathouse in 2005, believes that Wright may also have designed the barn and small house across the road from the Wallis Gatehouse. Wallis made notes about such things as gasoline consumption on the walls of the barn when he used it as a garage.

40. *Delavan Republican*, June 29, 1899.

41. *Delavan Enterprise*, July 31, 1902.

42. Letter to Marion Johnson from Frank Lloyd Wright, postmarked Spring Green, Wisconsin, October 17, 1946, from the collection of the Department of Architecture and Design, The Art Institute of Chicago, gift of Mrs. Richard Q. Livingston, Receipt of Object Number 39211. The letters of Frank Lloyd Wright or/and the office of Frank Lloyd Wright are used by permission and are copyright © The Frank Lloyd Wright Foundation 2018.

43. Marion Johnson Livingston letter to Thomas Eyerman, December 22, 1992. Quoted with permission of the Ryerson Library of the Art Institute of Chicago and Thomas Eyerman. It is not known what form those "little mementos" took. Wallis did, indeed, live on Forest Avenue, near Wright's Home and Studio, but not until several years after Penwern came into existence.

44. *The Cherry Circle*, November 1911.

45. Allen Buzzell, phone interview with the author, December 19, 2017.

46. Highlights of the construction of Penwern, as documented by Delavan's two weekly newspapers, are listed in Appendix 1.

47. *Delavan Enterprise*, June 28 and July 5, 1906.

48. *Delavan Enterprise*, August 24, 1905.

49. Ibid. Her husband's name and birthplace (Springfield, Illinois) are listed in her 1922 passport application. No record of his death has been found.

50. Leonard Eaton, *Two Chicago Architects and Their Clients,* Chicago: University of Chicago Press, 1968.

51. "Taken by Death," *Chicago Daily Tribune*, April 10, 1933.

52. "Ruling in Jones Will Suit," *Chicago Daily Tribune*, December 11, 1934.

53. Kate Allgeier, email to the author, June 10, 2013.

54. Jennifer Ho, archivist, Chicago Community Trust, email to the author, November 7, 2017.

55. Kathleen Staffa, phone interview with the author, September 12, 2014.

56. In 1936, the ring was valued at $125 ($2,310).

57. Jack Holzhueter, email to the author, September 7, 2016, recalling his conversation with Forster in 2001.

58. Jack Holzhueter, phone conversation with the author, November 12, 2013.

59. "Plan Open House Later in $20,000 Library Addition," *Pike County Democrat*, June 15, 1938.

60. "Fred Jones Leaves $25,000 for Annex To Local Library; Chicago Man, Former Resident, Also Willed His Own Library to City." *Pike County Republican*, May 31, 1933.

61. *Delavan Republican*, July 24, 1930.

62. Clari Dees, email to the author, January 5, 2016.

Chapter 2

1. The term "summer residence" is on some of Wright's plans for the house.

2. Jack Holzhueter, phone conversation with the author, June 19, 2013.

3. Grant Carpenter Manson, *Frank Lloyd Wright to 1910—The First Golden Age*, New York: Van Nostrand Reinhold, 1958, p. 102. Wilbert R.

Hasbrouck made a similar observation about the turnaround in business for architects in 1900 in his invaluable history of Chicago's architects, *The Chicago Architectural Club—Prelude to the Modern*, New York: The Monacelli Press, 2005, p. 272.

4. *Delavan Enterprise*, August 31, 1905. There are at least two anecdotal accounts of Wright at the lake, but they are undocumented.

5. John Major, interview with the author at Penwern, September 6, 2013.

6. Robert Hartmann, interview with the author at Penwern, August 16, 2017.

7. Construction dates are verified in contemporary newspaper accounts in the *Delavan Enterprise* and the *Delavan Republican* weekly newspapers. These were viewed on microfilm at the Aram Public Library in Delavan.

8. *Kankakee Daily* (Illinois) *Gazette*, October 31, 1900.

9. Janet Parks, "Architectural Drawing: Materials, Process, People," in Garry Bergdoll and Jennifer Gray, eds., *Frank Lloyd Wright: Unpacking the Archive*, New York: The Museum of Modern Art, 2017, p. 242.

10. Ibid., p. 236, and Hasbrouck, op. cit., p. 217.

11. Michael Bridgeman, interview with the author at Penwern, Sept. 2, 2016.

12. Frank Lloyd Wright, *An Autobiography*, New York: Horizon Press, 1977, p. 182.

13. Mark L. Peisch, *The Chicago School of Architecture*, New York: Random House, 1964, p. 52.

14. Jones bought most of the land comprising Penwern from Wallis. There are a half-dozen confirmed designs by Wright for Wallis, most unrealized. Some additional ones marked as being for Wallis may have been misidentified as having been for him. Wallis's relationship with Wright dated back to sometime between 1894 and 1897 when Wright designed a boathouse for him at the site of a cottage Wallis built in 1891, east of the future site of Penwern. Wright may also have designed what is known as the Wallis Gatehouse there. While the Wallis Gatehouse has been widely attributed to Wright, Bruce Brooks Pfeiffer offered the following caution: "Without a drawing we don't have the authority to authenticate it. . . . It does look like the Moore House [a home in Oak Park designed by Wright, across the street from his Home and Studio]," phone interview with the author, June 4, 2014.

15. Paul Kruty, phone interview with the author, January 18, 2018.

16. Robert Hartmann, email to the author, November 10, 2017.

17. Ibid.

18. Patrick J. Mahoney, AIA, email to the author, November 16, 2017; Paul Kruty, email to the author, December 19, 2017.

19. Henry-Russell Hitchcock, *In the Nature of Materials*, Boston: Da Capo Press, 1975, p. 23.

20. Ibid., p. 30.

21. Neil Levine, *The Architecture of Frank Lloyd Wright*, Princeton, NJ: Princeton University Press, 1996, p. 27.

22. Wright, *Autobiography*, p. 163.

23. Eric O'Malley for Wright Society, "East Meets West: Frank Lloyd Wright and the Ho-o-den," Geneva, IL: *Explore Wright*, Volume 01, Number 03, 2017.

24. Wright, *Autobiography*, p. 166.

25. Manson, *The First Golden Age*, 1958, p. 97.

26. Kruty, phone interview with the author, August 29, 2014.

27. Jonathan Lipman, "The Architecture of Arcadia," in *The Wright State: Frank Lloyd Wright in Wisconsin*, Milwaukee: Milwaukee Art Museum, 1992, p. 15. He described the boathouse as "demolished" because his essay was written fourteen years

Lind, Carla, *Lost Wright*, Washington DC: Archetype Press, 1996.

Lipman, Jonathan, "The Architecture of Arcadia," in *The Wright State: Frank Lloyd Wright in Wisconsin*, Milwaukee: Milwaukee Art Museum, 1992.

Mahoney, Patrick J., AIA, *Frank Lloyd Wright's Walter V. Davidson House: An Examination of a Buffalo Home and Its Cousins from Coast to Coast*, Buffalo, NY: State University of New York College at Buffalo, 2011.

Manson, Grant Carpenter, *Frank Lloyd Wright to 1910—The First Golden Age*, San Francisco: Pomegranate Press, 2006.

Martone, Fran, *In Wright's Shadow: Artists and Architects at the Oak Park Studio*, Oak Park, IL: The Frank Lloyd Wright Home and Studio Foundation, 1998.

Marty, Myron A., *Communities of Frank Lloyd Wright*, DeKalb, IL: Northern Illinois University Press, 2009.

McCarter, Robert, *Frank Lloyd Wright*, London: Phaidon Press Limited, 1997.

McCarter, Robert, ed., *On and By Frank Lloyd Wright: A Primer of Architectural Principles*, London, New York: Phaidon Press, 2005.

O'Gorman, Thomas J., *Frank Lloyd Wright's Chicago*, London: PRC Publishing, 2004.

Parks, Janet, *Architectural Drawing: Materials, Process, People*, in Garry Bergdoll and Jennifer Gray, eds., *Frank Lloyd Wright: Unpacking the Archive*, New York: The Museum of Modern Art, 2017.

Peisch, Mark L., *The Chicago School of Architecture*, New York: Random House, 1964.

Pfeiffer, Bruce Brooks, *Frank Lloyd Wright 1885–1916: The Complete Works*, Cologne: Taschen, 2011.

——, *Frank Lloyd Wright 1943–1959: The Complete Works*, Cologne: Taschen, 2009.

Pfeiffer, Bruce Brooks, in *Frank Lloyd Wright Monograph*, edited and photographed by Yukio Futagawa, Vol. 2, 1902–1906, Tokyo: A.D.A. EDITA, 1987.

——, *Wright*, Cologne: Taschen, 2003.

Riley, Terence, with Peter Reed, *Frank Lloyd Wright Architect*, New York: The Museum of Modern Art, 1994.

Ruth-Mariscano, Patricia, *Images of America: Delavan*, Mount Pleasant, SC: Arcadia Publishing, 2004.

Sloan, Julie L., *Light Screens: The Leaded Glass Designs of Frank Lloyd Wright*, New York: Rizzoli International Publications, 2001.

Smith, Kathryn, *Wright on Exhibit: Frank Lloyd Wright's Architectural Exhibitions*, Princeton and Oxford: Princeton University Press, 2017.

Storrer, William Allin, *The Frank Lloyd Wright Companion*, Chicago: University of Chicago Press, 1993.

Twombly, Robert C., *Frank Lloyd Wright: An Interpretive Biography*, New York: Harper & Row, 1973.

Visser, Kristin, *Frank Lloyd Wright & the Prairie School in Wisconsin*, Madison, WI: Prairie Oak Press, 1994.

Wallace, Joseph, *Past and Present of the City of Springfield and Sangamon County Illinois*, Volume II, Chicago: S. J. Clarke Publishing Company, 1904.

Wright, Frank Lloyd, *An Autobiography*, New York: Horizon Press, 1977.

——, *An American Architecture*, edited by Edgar Kaufmann.

Yadon, Gordon, *History of Delavan*, Delavan, WI: (self-published), 1976.

Index

About the Author

Mark Hertzberg is the author and photographer of three books about Frank Lloyd Wright's work in Racine, Wisconsin, all published by Pomegranate (*Wright in Racine*, 2004; *Frank Lloyd Wright's Hardy House*, 2006; and *Frank Lloyd Wright's SC Johnson Research Tower*, 2010). He is a contributing author to *Frank Lloyd Wright: Preservation, Design, and Adding to Iconic Buildings*, edited by Richard Longstreth, a book that grew out of the 2010 Frank Lloyd Wright Building Conservancy conference in Cincinnati. He has lectured widely on the subjects of his books about Wright's work.

He is also the author and photographer of a book commissioned by the First Presbyterian Church of Racine for its 175th anniversary and lead photographer for a book commemorating the fiftieth anniversary of The Prairie School.

Hertzberg chronicled daily life in Racine for *The* (Racine) *Journal Times* for thirty-three years as an award-winning photojournalist and as director of photography. He took an early retirement from the newspaper in 2012.

A native of New York City, Hertzberg graduated from Lake Forest College with a B.A. in international relations. He serves as secretary and newsletter editor for Wright in Wisconsin. He is an avid year-round bicyclist. He lives in Racine with his wife, Cindy.

Robert Hartmann